ARNOLD NEWMAN'S AMERICANS

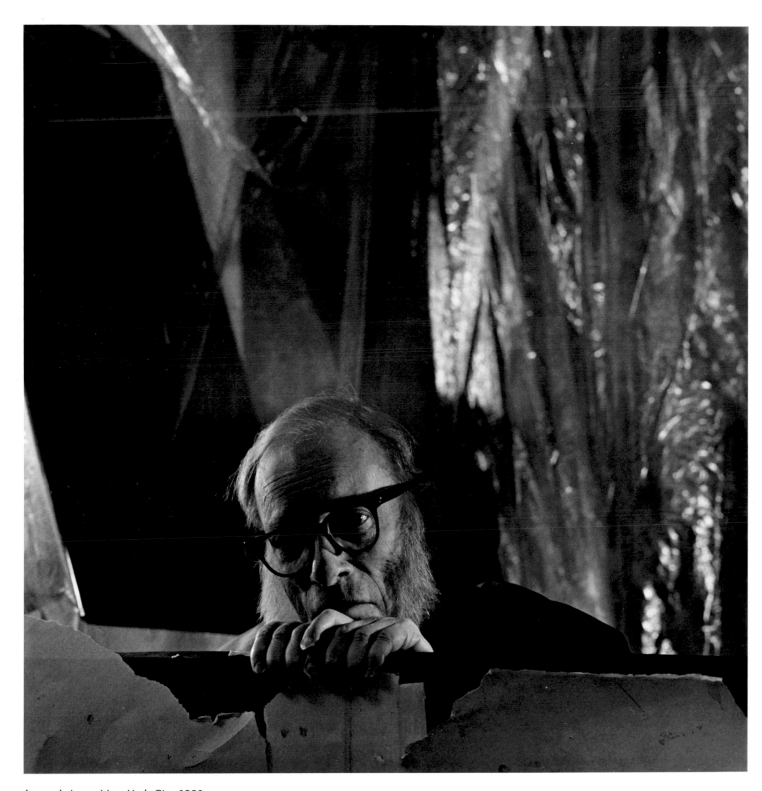

Isaac Asimov, New York City, 1990

ARNOLD NEWMAN'S
AMERICANS

ESSAYS BY ALAN FERN AND ARNOLD NEWMAN

NATIONAL PORTRAIT GALLERY · SMITHSONIAN INSTITUTION

in association with Bulfinch Press / Little, Brown and Company

Boston Toronto London

For my grandchildren Emma, Daniel, Sarah, and Mark, with love

An exhibition at the National Portrait Gallery
April 15 through August 16, 1992

Photographs and essay by Arnold Newman
copyright © 1992 by Arnold Newman
Compilation and essay by Alan Fern copyright © 1992
by Smithsonian Institution

Library of Congress Cataloging-in-Publication Data
are given on page 151.

First Edition

Bulfinch Press is an imprint and trademark of
Little, Brown and Company (Inc.)
Published simultaneously in Canada by
Little, Brown & Company (Canada) Limited

PRINTED IN THE UNITED STATES OF AMERICA

CONTENTS

Arnold Newman, New York City, 1987

ARNOLD NEWMAN'S AMERICANS

In a professional career extending over half a century, Arnold Newman has established himself as one of the most productive and distinctive portrait photographers of our day. In celebration of his life as a photographer, this collection – representing his best American portraits – has been added to the holdings of the National Portrait Gallery.[1] It forms the subject of the latest in the series of special exhibitions at the Gallery to be devoted to the masters of photographic portraiture. Now gathered in this book as a salute to the photographer, these memorable images from the national collection record the exceptional relationship between a remarkable artist and many of the notable people of his time.

Ample documentation of Newman's life and career exists in the several books already published on his work, so it would be redundant to rehearse his biography in detail here.[2] But, in the course of preparing this selection of his photographs, Newman talked at length with William F. Stapp, then the curator of photographs at the Portrait Gallery, and in their conversations he expanded on aspects of his early life, on his attitudes toward his work, and on his development as a person and as an artist.[3] In the midst of this project, Will Stapp moved from the National Portrait Gallery to the George Eastman House to begin a new curatorial job, leaving to this longtime admirer of Newman the pleasant task of preparing these introductory pages – which have been enhanced by some of the observations that emerged in the interviews.

Born in New York City in 1918, Newman spent his early youth in Atlantic City, where his family had moved for business reasons. When they relocated to Florida, he finished high school in Miami and entered the University of Miami in 1936 to study painting. His decision to pursue art, and then photography, was supported by his close-knit family, though they had little idea of what this path involved. As the Depression took its toll on his family's finances, Newman was obliged to leave school and go to work. When offered a job by a family acquaintance, Leon A. Perskie, who operated the photo studio at the Lit Brothers Department Store in Philadelphia, he moved north and learned the rudiments of his trade. Newman recalls that his father later said of photography: "Great. It's a business, it's an art, it's a profession. You can always earn a living." "And he was right," Newman added recently – a judgment he probably would not have made in 1938.

When he returned north from Florida, he joined an old friend from his Atlantic City days, Ben Rose, who had been studying with Alexey Brodovitch in Philadelphia. Rose introduced Newman to twentieth-century French painting, and he began to look at the photographs then being published in magazines such as *Vanity Fair* and *Harper's Bazaar,* as well as at the work being done by the photographers of the Farm Security Administration. Late in 1939, he moved back to Florida to manage a commercial portrait studio. He recalls that he was dissatisfied early on with the limitations of the photographic studio and was determined to photograph outside the studio.[4] Inspired by the social documentation of the FSA photographers, Newman photographed people and places in the poorer sections of West

Palm Beach with a hand-held camera he had borrowed[5] and found that he could effectively combine the photographic techniques he had mastered in his studio work with the sure sense of composition he had developed as a student of painting and drawing.

Visiting New York in 1941, he stopped to see Beaumont Newhall, who had organized the department of photography at the Museum of Modern Art. Newhall suggested that Newman improve his printing technique and showed him prints by Edward Weston and Ansel Adams as models. Newhall thought that Newman's work showed promise and arranged for him to see Alfred Stieglitz at his gallery, An American Place. The encounter with Stieglitz inspired and encouraged him. Determined to test whether he could manage a career in New York, Newman began to show his work to others, and when he was offered an exhibition, along with his old friend Ben Rose, at the gallery operated by Dr. Robert Leslie of the Composing Room, he decided to move to New York. Since the Composing Room did typesetting for many of the major magazines, advertising agencies, and publishers in New York, the work of these two young photographers fortunately came to the attention of many important figures in the New York art and publishing worlds. Beaumont Newhall and Ansel Adams came to the exhibition opening, and Newhall gave encouragement by purchasing a print – the first of the many Newman photographs acquired for MOMA.

Newman was obliged to return to Florida shortly after the start of World War II, to present himself for military duty. He was deferred but needed to stay there, so he opened his own portrait studio in 1942, visiting New York whenever he could until 1946. In that year, he moved north permanently and received his first assignments for *Life* and *Harper's Bazaar*. Newman's professional career began to take shape slowly but steadily; meanwhile, he continued to do his own work when he could, and starting with a portrait of Raphael Soyer, he commenced the informal series of portraits of artists that has continued to this day.

There is probably no better way to understand the individuality of Arnold Newman's work than to look closely at one of his photographs. Among the most frequently reproduced and shown of his portraits is the image of Igor Stravinsky, his head leaning on his arm, seated at the end of a silhouetted piano (plate no. 18). It must drive Newman wild that as rich and prolific a career as his is so often summarized in a single image; yet the Stravinsky picture so powerfully represents Newman's characteristic way of seeing that it serves as an admirable introduction to his work. It clearly belongs to the family of pictures we call "portraits," yet it is startling, since the head of the subject occupies only a small area of the composition. The space not occupied by the sitter assumes great importance; the fact that the man is depicted in association with a piano suggests that this is a musician.[6] The intensity of Stravinsky's gaze is combined with a curiously languid weariness that eloquently evokes the man, and the figure is given special prominence through the powerful geometry of the piano and wall behind. Stravinsky's face and hand are rendered in a full range of tonalities; the larger area of the photograph appears at first glance to be rendered only in black, white, and one shade of gray. Closer examination shows that this is far from the case, and the background wall tonality deepens in value as it progresses toward the right edge of the image.

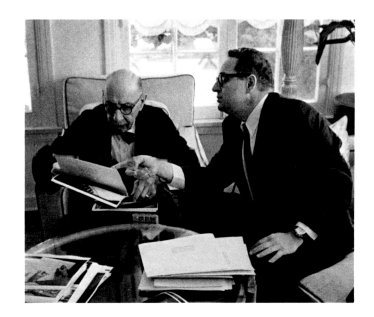

Newman reviewing photographs
with Igor Stravinsky for *Bravo
Stravinsky,* 1967

I have described this well-known photograph at such length in order to suggest that it is
more complex than is revealed at first glance. It is a subtle symphony in monochrome pho-
tography, a daring composition in an unconventional format, and an unusual approach
to portraiture. It stands on its own as a work of graphic art in much the same way that a
poster by Toulouse-Lautrec does; it is at once arresting and subtle, unconventional and
easily comprehended. Once seen, it will not be quickly forgotten. This is not the only photo-
graph Newman has made of Stravinsky; he returned to the composer several times over the
years, finally publishing a book (*Bravo Stravinsky*) devoted to him. Yet the image of
Stravinsky at the piano, by virtue of its originality of conception, stands out from the group.

Some portrait artists make their mark through the creation of an indelible image of a partic-
ular sitter, but this is not really Newman's intention. He has rarely made his impact through
the creation of the single, definitive image of a famous face. Instead, as in his photograph
of Stravinsky, he explores his subject in depth, finally arriving at an image memorable for
its compositional strength, for its association of a man with one of the tools of his trade, and
for its arresting appearance of simplicity. We learn much about Stravinsky as a man, but not
from an overpowering delineation of the composer's features. As in this photograph, New-
man often locates the sitter at the far edge of the picture area, at the left or right margin, or
occupying the lower third of the composition (rarely the upper portion!). Placing the subject
in a working or living space, he gives special emphasis to the pose and engages the viewer
to join in the search for the personality that was revealed to the photographer.

Not all of Newman's photographs function in this way, of course. His personal style is not
as immediately apparent as that, for example, of Irving Penn, Richard Avedon, or Yousuf
Karsh. The heads of some sitters — President Truman, President Eisenhower, sculptor David
Smith (plate nos. 16, 10, and 43) — almost fill the frames of their portraits. Photographer Paul

Strand, in a calm and reflective attitude, faces us in a three-quarter-length pose, with his head placed at about the center of the picture area (plate no. 6). Georgia O'Keeffe and Alfred Stieglitz are turned at 90 degrees from each other, with their heads at very different levels in the composition (plate no. 45).

Sometimes, his subjects almost seem to hide (playfully, as in the case of I. M. Pei, plate no. 53, peering through the receptionist's window in his office), while at other times they are artfully placed in a patterned field (as is critic Brooks Atkinson, against a field of empty theater seats, plate no. 73). Newman often places a chandelier or lighted ceiling in the entire upper half of the composition, inviting the viewer to respond to the room as well as to its inhabitant. Newman's photographs always seem to be lighted naturally, but this is an illusion. He remarked to Will Stapp, "I would use the existing lighting when it was good, and add to it, and do all kinds of things. I'm a great light man. I can do tricks with lighting [as well as anybody]." This is borne out by the fascinating informal location photographs reproduced in *One Mind's Eye*,[7] where it can be seen that Newman even carried lights to outdoor locations, as when he photographed Edward Kienholz for *Look* magazine in 1967.

Newman believes that "people exist in space," and this is the underlying principle in his "environmental portraits." These were in striking contrast to the pictures of people normally being published in American magazines immediately before he came upon the scene, and this difference established him as an innovator with a highly individual approach to his subjects. He makes a "conscious effort to depict where [his subjects] lived or worked, and bring it together into a creative whole [to] make it say something." Working on location outside the studio can have its hazards, but Newman finds that entering a new environment is stimulating. Photographer and historian Arthur Ollman characterized him as functioning "with a fine jazz improvisational instinct."[8] Newman explains, "You leave your mind open for discovery.... The best accidents happen to the best photographers." His method of working is very different from that of Penn or Avedon: "They totally control the situation in the studio, and I am always taking a chance wherever I go.... Sometimes it defeats me. But I would rather take that chance where an element will give me something to work with." For

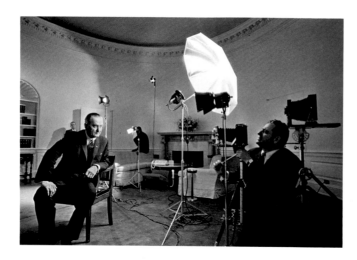

Newman making Lyndon B. Johnson's official presidential portrait at the White House, 1963

Newman, "photography is very exact, very deliberate." Although Newman comes across as an impulsive, sentimental, even passionate person, his photography is highly controlled, rational, and constructed, even when it is subject to the accidents of working in an unfamiliar setting.

For all his concentration on the technical issues of photographic portrayal, Newman is totally conscious of the predicament of his subjects. He knows that, for most people, even movie stars accustomed to facing the lens, "the most self-conscious act in the world is to pose for a photograph. People feel ill at ease." He tries to prepare himself thoroughly with information about his subjects and to show empathy when they meet. Trying "to get behind the mask" (as Newman puts it) is the challenge faced by all photographers; he is fascinated with the psychology of those he photographs and is inspirited by the new problems posed by every portrait.

Once the photographs have been shot, the issue of printing them remains, and here yet another element of creative control enters. Ollman reported that "in his studio dozens of different printings and croppings are sampled to find the most compelling. A set of matboard L's constantly move over a contact print to carve a precise cropping . . . to empower an image."[9] Newman never seems to be content to accept a decision about the framing of one of his photographs without questioning it again and again, when he reviews an older picture for a new use. He recapitulates his creative processes as he tests the composition for new possibilities, shaving off a half-inch here, or adding a quarter of an inch there. As often as not, the initial decision stands, but the quest for a more eloquent symbol of his subject remains.

Newman is by no means committed to using the entire frame of his negative in the finished print. A telling example is shown in *One Mind's Eye*, where twelve contact prints from a sitting with Picasso are reproduced.[10] After rejecting a number of the negatives in favor of others, Newman has indicated on the contact sheet the close cropping he has arrived at for the full-face photograph of the painter; the original shot would have placed Picasso's head in the lower half of the picture area — one of Newman's frequently used devices — but he sensed the power that would be lost if this were to be his choice. Instead, he eliminates the background, giving Picasso's head and hand a monumentality they would have lacked had the full negative been printed.

Arnold Newman has never ceased to work as an artist does, even though he put aside his brushes and paint long ago in favor of the camera. As curator and critic Henry Geldzahler has observed, Newman has a special respect and empathy for visual artists, considering himself one.[11] "Painting and photography are really intertwined," Newman has observed, "and should not imitate one another." Surely his understanding of composition, his deft placement of objects in the picture area, and his exceptional sensitivity to the styles and personalities of the painters and sculptors he has photographed all come from his formal studies in the visual arts as well as from his inherent visual gift.

When Newman first started to photograph artists, he was encouraged (by Raphael Soyer) to exchange a print of his for a painting, drawing, etching, or watercolor by his subject; both

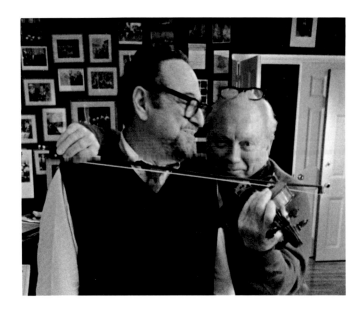

An interlude during a photo session with Isaac Stern in 1988. Newman has photographed Stern more than ten times since 1957.

the artist and the photographer seemed to agree that their work was related in its creativity and individuality. From time to time, Newman even departs from the "straight" photographic path and carries creative control even farther in the collages he assembles from existing photographs. It delights him to discover compositional elements in several photographs from a session that can be combined to telling effect, achieving a final composition that would have been impossible if only the untouched negative was used by itself. Infrequently, he has used deliberate double exposure to overlay images (as in his 1970 portrait of Barnett Newman, plate no. 51), but in other instances, he cuts or tears the prints apart and glues the elements into a new arrangement. No doubt there is a creative affinity with the synthetic cubist paintings of Braque and Picasso, which incorporated printed papers, cigarette packets, and other found objects into the composition, or with the assembled images of such recent artists as Robert Rauschenberg. But the clarity and coherence of the finished collage is entirely consistent with the reasoned, constructed approach seen in all of Newman's work.

No wonder that Newman has never wanted to sacrifice this freedom of fresh thinking to serve as the staff photographer for a single magazine. Despite the fact that he has spent most of his career working for publications, submitting his work to the scrutiny and judgment of editors and art directors, Newman insists on remaining independent in his approach to his work. He is "not a company man" and "would rather go hungry than have somebody tell me how to make my pictures." He needs to preserve the freedom to react to the happy accidents he discovers, to respond to the possibilities of a subject's environment, to solve a technical problem posed by a location.

This collection of Arnold Newman's work allows us to appreciate his considerable achievement in depicting such a broad range of subjects with such variety. He brings us face-to-face with the pixieish personality of Danny Kaye, the determination of Harry S Truman, the craggy solidity of Edward Hopper (plate nos. 78, 16, and 60). He evokes the rationality of Piet

Mondrian as well as the frenzy of Jackson Pollock (plate nos. 2 and 41). The artist inhabits his studio, the statesman his elegant suite, the poet his forest. Newman delights in getting to know his subjects, and (sometimes to his astonishment) many have become personal friends. Each of Newman's photographs vibrates with the personality of the sitter and usually informs us about the significance — or at least the profession — of the subject; at the same time, each is the result of the artful control and sensibility of the photographer.

It has to be mentioned that this selection of portraits, excellent as it is, does not represent all aspects of Newman's achievement. I have mentioned the Picasso portrait as an example of one aspect of the creative process used by Newman, but it is not included here; since these photographs are now part of the collections of the National Portrait Gallery, they all depict people who have worked and lived in the United States, in consonance with the Gallery's mission to collect and display portraits of men and women who have contributed notably to the life of this country. Newman has made memorable photographs of European artists, industrialists, and statesmen, as well, just as he has photographed still lifes, abstract compositions, and landscapes; even though they lie outside the scope of this particular collection, they are still a significant part of his work. But Newman is quintessentially an American photographer. He lives and works in New York, and most of his assignments have come from American clients. Consequently, there is perhaps a special suitability that this group of his photographs has America as its focus.

Newman resists being characterized as a "portrait photographer." Perhaps this is too reminiscent of his early days as an apprentice commercial portrait photographer in the Lit Brothers Department Store in Philadelphia, his subsequent management of a portrait studio in Florida, or his own first business — an independent portrait photography establishment. He has long since eschewed the repetitive-formula posing, retouched negatives, and vignetted prints of the conventional portrait studio in order to function as the artist he originally meant to become.

In 1957, Newman observed that there was a contrast between painting and photography. "A painting is a matter of creative *distortion,* and photography is a matter of creative *selection.* . . . Inevitably there is a great deal of the photographer in the finished product. . . . If there isn't much of him, then there isn't much of a portrait. In other words, the photographer must be a part of the picture. It's a matter of joining forces with the sitter, in a sense."[12]

In "joining forces," Newman has produced a body of work that is remarkable for its personal style, its variety, and its brilliance, winning him a place among the foremost photographers of people in his generation. While he is aware that his creative gifts are considerable, and he has not been shy about asserting his significance as a photographer, he is genuinely surprised that he is as well known as he is and that he has enjoyed such a brilliant career. At this stage of his life, it is obvious that he works because he loves it, despite the many uncertainties of the independent artist's existence. His photographs appeared in *Life, Look,* and *Holiday* in the great days of those periodicals; the magazines have disappeared or changed, but Newman continues, in his seventies, to work with undiminished vigor for a variety of corporate and individual clients.

It is fortunate that this distinguished body of work has found its place in the National Portrait Gallery, and it is a happy circumstance that we are able to bring this special group of photographs together in this book for the enjoyment of viewers today and in decades to come.

Alan Fern
Director, National Portrait Gallery

NOTES

1. This collection has been selected by Arnold Newman, in collaboration with William F. Stapp (then curator of photographs at the National Portrait Gallery) and Beverly J. Cox (curator of exhibitions).

2. Among these books are: *One Mind's Eye: The Portraits and Other Photographs of Arnold Newman,* with a foreword by Beaumont Newhall and an introduction by Robert Sobieszek (Boston: David R. Godine, 1974); *Arnold Newman: Five Decades,* with an introduction by Arthur Ollman and an afterword by Arnold Newman (New York, San Diego, and London: Harcourt Brace Jovanovich, 1986); Bruce Weber, *Arnold Newman in Florida* (West Palm Beach, Fla.: Norton Gallery of Art, 1987); *Artists: Portraits from Four Decades by Arnold Newman,* with a foreword by Henry Geldzahler and an introduction by Arnold Newman (Boston: New York Graphic Society, 1982).

Biographical information here has been adapted from these publications, and confirmed and expanded in the course of our interviews with Mr. Newman.

3. The extended conversations between Will Stapp and Arnold Newman that took place in February 1991 were transcribed from tape recordings. The quotations from Newman not otherwise credited come from these interviews.

4. *One Mind's Eye,* xi.

5. These West Palm Beach images are published in Bruce Weber, *Arnold Newman in Florida.*

6. In his 1991 conversation with Will Stapp, Newman recalls that some uninformed commentators on the Stravinsky photograph have assumed that he was a pianist; Newman is often troubled when his symbolic intention is misunderstood, or taken too literally.

7. *One Mind's Eye,* x.

8. *Arnold Newman: Five Decades,* vii.

9. Ibid., vii–viii.

10. *One Mind's Eye,* xvi.

11. *Artists,* 5.

12. Arnold Newman and Arthur Goldsmith, "A Popular Photography Tape Interview: Arnold Newman on Portraiture," *Popular Photography* 40, no. 5 (May 1957): 125–126, quoted in *One Mind's Eye,* viii.

CHRONOLOGY

1918 March 3: born, New York City

1920 1946 Lives with family in Atlantic City, New Jersey, and Miami Beach, Florida

1936 1938 Receives working scholarship to University of Miami art classes

1938 Leaves school because of financial problems; works in Philadelphia portrait studio; starts personal work

1939 Works in Philadelphia, Baltimore, and Allentown, Pennsylvania, for same portrait studio
Meets Alfred Stieglitz in New York
Begins "cutout" experiments
December: becomes a studio manager in West Palm Beach, Florida

1941 June: visits New York City and receives encouragement from Beaumont Newhall and Alfred Stieglitz
September: returns to New York for two-man exhibition (with friend Ben Rose), A D Gallery; remains there until June 1942
Museum of Modern Art purchases first Newman prints
Begins "experimental" portraits, using artists as subjects
December–January 1942: one-man exhibition, "Artists Through the Camera," Brooklyn Museum

1942 Receives first assignment from *Harper's Bazaar*

1942–1945 Operates own studio in Miami Beach; continues portrait series of artists on visits to New York

1945–1946 One-man exhibition, "Artists Look Like This," Philadelphia Museum of Art; this exhibition is widely circulated

1946 Moves to New York; receives assignments from *Harper's Bazaar, Life, Fortune,* and other publications
Photographs Eugene O'Neill – first *Life* assignment – and takes first photographs of Igor Stravinsky

1947 Does first *Life* cover

1948 Begins advertising assignments

1949 March 6: marries Augusta Rubenstein
Group exhibition, "In and Out of Focus," Museum of Modern Art
Portrait assignment for *Portfolio* begins long association with art director and editor Frank Zachary, continuing later at *Holiday, Travel & Leisure,* and *Town & Country*

1950	"What Do U.S. Museums Buy?" – photo essay for *Life*
	May 9: son, Eric Allan Newman, born
1951	One-man exhibition, Camera Club, New York
	Begins photographing *New York Times* advertising executives and writers; continues through 1958
	Receives first of continuing assignments for *Holiday*
	Receives Photokina Award, Cologne, Germany
1952	March 26: son, David Saul Newman, born
	Does portraits of presidential hopefuls – including Dwight D. Eisenhower, Adlai Stevenson, and Robert A. Taft – for *Life*
1953	Photographs future presidents John F. Kennedy, Lyndon B. Johnson, and Richard M. Nixon for *Holiday*
1954	Makes six-month photographic trip through Europe for various publications; photographs English Parliament, people and places of Italy, heads of Scottish clans, and German heads of state; also photographs Pablo Picasso, Giacometti, and other artists
1955	Does "American Arts and Skills" series for *Life;* culminates in book of same title published by Dutton
	One-man exhibition, Limelight Gallery, New York
1956	Photographs presidential candidates for *Life* cover series, including John F. Kennedy, Dwight D. Eisenhower, and Richard M. Nixon
	Photographs Georges Braque in France for *Holiday*
	Photographs Jean Dubuffet and Pablo Picasso for self
1957	Receives first Photojournalism Conference Award, University of Miami, Coral Gables
	Receives Financial World Annual Report award for Ford Motor Company, "Best 1957 Annual Report, All Industries"; many annual reports for key corporations follow over the years
1958	October-December: travels to Africa for *Holiday,* photographing village life and tribal leaders in ten countries
1959	Travels to Israel for *Holiday*
1960	Does photo essay on Cape Cod artists for *Horizon*
1961	Does Rothschild family portraits for *Holiday*
	Receives Newhouse citation, Syracuse University, and the Philadelphia Museum College of Art citation
1962	Contracts with Simon & Schuster to do book of portraits with text by Carl Sandburg; Sandburg, living with Newmans, becomes ill and is unable to continue; project canceled

1963	Does photo essay of location still lifes, "The Americans in My Mind," for *Holiday*
	Makes group photo of President John F. Kennedy's advisers for *Holiday*
	Photographs Alfried Krupp in Germany for *Newsweek*
	Photographs the Louvre and does other European photo essays for *Holiday*
	Does Lyndon B. Johnson's official portrait and Johnson essay for *Look*
	One-man exhibition, Fourth Biennale Internazionale della Fotografia, Venice, Italy; awarded its gold medal

| 1964 | Does photo essay on Spain and Spanish personalities, including Francisco Franco, for *Holiday*; also photographs German personalities and Yale architects for *Holiday* |

1965	Assigned most of photography work for *The Smithsonian Institution*, published by American Heritage
	Does photo essay on Israel Museum for *Look*
	Named adviser and acting curator to Photography Department, Israel Museum, Jerusalem

| 1966 | Begins IBM advertising series, which continues for two years |
| | Commissioned by Time-Life Books to photograph Stravinsky |

| 1967 | *Bravo Stravinsky* published |

| 1968–1969 | Does special photography for films in France and England |

| 1970 | Does photo essays on United States and Europe for *Holiday* |

| 1971 | Does first assignments for *Travel & Leisure* magazine |

| 1972–1973 | Signs with Light Gallery, New York City; has one-man exhibition there |
| | One-man exhibition, "Photographs from Three Decades," International Museum of Photography at George Eastman House, Rochester, New York |

| 1974 | *One Mind's Eye: The Portraits and Other Photographs of Arnold Newman* published; photographs from book exhibited at Light Gallery, New York City; exhibition travels around country |

1975	Receives American Society of Magazine Photographers "Life Achievement in Photography" award
	Gives series of lecture/workshops in California, including first workshop with Ansel Adams in Yosemite; begins lecturing worldwide
	One-man exhibition, David Mirvish Gallery, Toronto

| 1976 | Commissioned by Kinney Shoe Company to photograph "great American faces" throughout the United States for exhibition celebrating the United States Bicentennial; *Faces, U.S.A.* published two years later |

Subject of television film produced by Nebraska Educational Television Network, "The Image Makers – The Environment of Arnold Newman"
Begins association with Maine Photographic Workshop
One-man exhibition, Galerie Fiolet, Amsterdam

1977 Begins series of 8 x 10-inch Polacolor portraits commissioned by Polaroid Corporation
One-man exhibition, "Arnold Newman – Recent Photographs," Light Gallery, New York City

1978 One-man exhibitions, Israel Museum, Jerusalem, the Tel Aviv Museum, and Moderna Museet, Fotografiska Museet, Stockholm
Commissioned by National Portrait Gallery, London, to photograph "The Great British," featuring fifty photographs of politicians, writers, artists, composers, etc.

1979 "The Great British" exhibition opens, National Portrait Gallery, London; *The Great British,* which accompanies the exhibition, published in England and United States

1980 *Artists: Portraits from Four Decades* published; selected photographs from book exhibited at Light Gallery, New York City
One-man exhibition, Lowe Art Museum, University of Miami, Coral Gables, Florida
Artist-in-residence, Quad City Arts Council, Rock Island, Illinois

1981 Receives honorary doctorate from University of Miami, Coral Gables, Florida
Makes extensive tour of Australia and Japan, lecturing and exhibiting in both countries, including a one-man exhibition, Photo Galerie International, Tokyo
Selected images from *Artists: Portraits from Four Decades* published in *Camera Arts* magazine
Gives first of William A. Reedy memorial lectures for Kodak

1982 Does extensive photographic tour and work in Israel
Portraits and abstract photographs commissioned by and published in *J D Journal,* Moline, Illinois
Subject of television film "The Photographer's Eye: Arnold Newman" produced by Crosscountry Cable Corporation, New York

1983 *I Grandi Fotografi – Arnold Newman* published in Milan, Italy; later published in English and Spanish
Signs with Daniel Wolf Gallery, New York City
Receives "Andy Award of Excellence" from Advertising Club of New York

1984 One-man exhibition, "Arnold Newman: Other Photographs," Daniel Wolf Gallery, New York City, featuring nonportraits, abstract, and semiabstract images

Portraits of artists exhibited, Seibu Department Store, Tokyo, and Iwaki Municipal Art Museum, Japan
One-man exhibition, Galerie Octant, Paris
Conducts workshop and lectures at the Norges Fotografforbund in Oslo and Sundvolden, Norway

1984–1985 Portraits of artists in group exhibition, "La Granda Parade," Stedelijk Museum, Amsterdam

1985 Receives honorary doctorate, Art Center College of Design, Pasadena, California
Receives Missouri Honor Medal for Distinguished Service to Journalism, University of Missouri, Columbia
Commissioned by Nikon, Inc., to do series of portraits, "Newman and Nikon"
In group exhibition, "American Images – Photography, 1945–1980," Barbican Art Gallery, London
"A Mover Amongst the Shakers," essay and photographs of Shaker Village, Hancock, Massachusetts, published in *American Photographer*
Conducts workshops in Canada, California, Maine, Washington, and Florida

1986 Named honorary fellow, together with Augusta Newman, Israel Museum, Jerusalem
June: retrospective exhibition, "Arnold Newman: Five Decades," opens at Museum of Photographic Arts, San Diego, California; exhibition travels to key museums in the United States and Europe
Arnold Newman: Five Decades published
One-man exhibition, Pori Art Museum, Finland, and Photographic Museum of Finland, Helsinki; gives lectures and workshops at both museums
Commissioned by the Norton Gallery of Art to photograph the West Palm Beach, Florida, area
Receives Lotus Club Medal of Merit, New York City

1987 One-man exhibition, "Arnold Newman in Florida," in conjunction with the retrospective exhibition, "Arnold Newman: Five Decades," Norton Gallery of Art, West Palm Beach, Florida
Arnold Newman in Florida published

1988 In group exhibition, "Picturing Greatness," Museum of Modern Art, New York City
In group exhibition, "Master Photography in the Fine Arts, 1959–1967," International Center of Photography, New York City
In group exhibition, "The Instant Likeness: Polaroid Portraits," National Portrait Gallery, Smithsonian Institution, Washington, D.C.
Conducts workshop and lectures to the Svenska Fotografernas Forbund (Swedish Photographers Association), Gothenburg, Sweden

One-man exhibition, "Collages and Recent Photographs," Sidney Janis Gallery, New York City
Publications, exhibitions, and celebrations mark Newman's seventieth birthday and fifty years in photography

1988–1989 In group exhibition, "5 X 5," El Museo de Arte Contemporaneo de Caracas, Venezuela

1909 Receives honorary doctorate, University of Bradford, England
In group exhibition, "Camera Portraits," National Portrait Gallery, London
Exhibition of portraits, collages, and abstractions, sponsored by United States Information Agency, in Old Town Hall, Prague; exhibition travels to Brno and Bratislava, Czechoslovakia, Budapest and Debrecen, Hungary
Receives Ministry of Culture of the Czech Socialist Republic's Honorary Commemorative Medal in celebration of the 150th anniversary of photography
Receives award for "Achievement and Contribution to Photography" from Photographic Society of Japan

1990 Receives honorary doctorate, the New School, New York City

1991 Named director's visitor, Institute for Advanced Study, Princeton, New Jersey
In group exhibitions, "Artist's Choice – Chuck Close Head-on/The Modern Portrait" and "Art of the Forties," Museum of Modern Art, New York City
In exhibition of contemporary photographs (1960–1979) from the Toppan Collection, Tokyo, at the International Center of Photography, New York City

1992 One-man exhibition, "Arnold Newman's Americans," National Portrait Gallery, Washington, D.C.; Arnold Newman's Americans, which accompanies exhibition, published

INTRODUCTION

During a recent visit to the Institute for Advanced Study at Princeton, its director, Dr. Marvin ("Murph") Goldberger, startled me with his observation of my work: "Arnold, you have photographed just about everybody who has been involved with the atomic bomb."

I knew that there were some notable exceptions, but when I reviewed my files and library, I realized that I had photographed a surprising number of key figures: notable American scientists such as Robert Oppenheimer (plate no. 87) and Leo Szilard, and European scientists as well. This also extended into the political arena, with President Truman (plate no. 16) and David Lilienthal, chairman of the Atomic Energy Commission.

This realization proved typical of my work and life. The passage of half a century of photographing people, both for myself and for clients (such as *Life, Look, Holiday,* and *Time*), has given me the incredible opportunity of being an observer and recorder of a cross section of the history of our times: politics, music, architecture, literature, psychology, and especially the world of art.

Coincidences and overlapping connections seem to always play a part in bringing these many worlds together. An example – I met Dr. Goldberger when I was asked to do a story on the Institute for Advanced Study at Princeton by *Town & Country* magazine. Dr. Goldberger is in the foreground of the group photograph of the Fellows of the Institute for Advanced Study (plate no. 26); he is one of the "Americans." Not only is he a distinguished physicist and former president of the California Institute of Technology, but he surprised me by mentioning that he had met and married his wife, Mildred, when they were both young with new bachelor of science degrees, working on the Manhattan Project – again the atomic bomb connection.

In 1991 I was invited back to the Institute for a stay as the "director's visitor" and as a lecturer. I found the coincidences and connections in abundance, and they were very informative. I learned much more from Murph and the other faculty members about Oppenheimer – the other side of the man with whom I had had a pleasant though brief acquaintance. I had heard about his reputation for being difficult, but those who knew him during his directorship at the Institute saw a more incisive personality, enabling me to better understand the tension unexpectedly revealed in my portrait of him in the "Americans."

I had also photographed the eccentric genius Kurt Gödel at the Institute in 1956 (plate no. 30). Many felt that his mathematical work was almost as important as that of his close friend Albert Einstein. But it was sad to hear the stories about Gödel, who ignored medical advice and literally starved himself to death.

Einstein? He died only four days before I had an appointment to photograph him. His spirit still seems to hang over Princeton after all these years.

During my stay at the Institute, Murph, his wife Mildred, my wife Augusta, and I discovered we had mutual friends, as we did with a number of the great scholars I met who were in

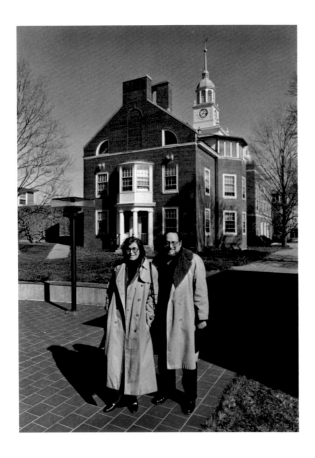

Arnold and Augusta Newman at the Institute for Advanced Study, Princeton, New Jersey, 1991

residence at the Institute. This was a typical experience for me, and such coincidences and connections are not only pleasant but often open up more doors and photographic opportunities.

In the art world, my first "environmental portrait subject" was Raphael Soyer in 1941, who after a long session insisted that I immediately meet and photograph Chaim Gross, the sculptor. I walked the few blocks with my equipment, guided by his model, Tina Bloom. The portrait I took that day of Chaim Gross is in the "Americans" (plate no. 37). That first day of making portraits resulted in two close lifelong friendships. Not long afterward, I made the double portrait of Raphael Soyer and his twin brother, Moses, also in the "Americans" (plate no. 42). Similarly, years later, when I was photographing Picasso, he offered to telephone Matisse to pave the way for me to photograph him — only to be visibly crushed by the news that Matisse was terminally ill. These kinds of contacts and introductions have been common throughout my career. But it was also the commissions of various publications that enabled me to meet — as well as to photograph — so many of the fascinating personalities of our time.

I was also assigned to do still lifes, food, museums, historical essays, and yes, even fashion, which I happily dropped, giving up a lucrative source of income. Soon, however, portraits became my principal activity and love.

I could not, and did not, depend on assignments to enable me to reach all the people I wanted to photograph. While I had an "understanding" with a number of the magazines I worked for, I never accepted a staff position or was under contract. By experience and personal choice, I knew that I had to be my own boss and patron.

Taking advantage of assignments all over the world, I would take additional time to make the images I wanted for myself. Of course, many of the people, and frequently the places, I was assigned to photograph were just the ones I would want to do as well.

During my first three years of photography, I had begun to find my way, influenced by the Farm Security Administration photographs and abstraction, producing my own experimental collages. All the while, I was repelled more and more by the sterile studios I was working in, and ideas about photographing people began to rummage about in my mind.

Coming to New York for my first show in 1941, I decided to stay and experiment with my ideas about portraiture. I had studied and admired the work of many of the master photographers of our time – Stieglitz, Steichen, Evans, Man Ray – but what I saw was not quite what I had in mind. Some of the FSA's photographs were of particular interest, but I knew I had to go my own way.

As I began to experiment, I realized that the perfect subjects were the artists – painters, sculptors, and photographers – who had been my youthful heroes. I was very familiar with their work and ideas, and as I expected, their studios and homes offered an inexhaustible source of material to work with. As a group, they gave me the greatest opportunities to explore the undefined visual concepts forming in my mind. These photographs were not meant to become a series of artists but became the basis of what my work would be in the future.

I have never been interested in simply photographing personalities. It is more important for me to interpret my subjects with all the creative controls I have at my disposal. I select certain people because they lend themselves to the visual concepts I wish to explore. I abhor the phrase and concept "celebrity photographer."

It has always been my need to photograph people with my own creative visual ideas, wedding them graphically and conceptually in order to make a statement about them and my work, attempting to achieve a timeless common denominator of that subject. Inevitably, photographs – like all art forms – reflect the time in which they are made. In general, I "build" rather than "take" a photograph, to differentiate it from the "candid" picture. This stems from my innate personal sense of the visual, which first turned me toward painting. The subject's environment – its furniture, vistas, and objects – provides not only the building blocks of design and composition but also the atmosphere created by the subject. These objects that surround the subject are *not* props, and should not be, but are *real*, integral parts of his life.

By using my ideas and placing the subjects in their milieu, my early work attracted significant attention. Through publication and exhibition, this approach became known as "envi-

ronmental portraiture." But ideas are always developing and changing, and they are often contradictory. I found it natural and exciting to pursue an open-ended attitude. Because of this and the physical limitations of working on location, the photographs became many things: abstract, surrealistic, symbolic, or what have you. I freely use collages, cutouts, anything that comes to mind at that moment. Labels come after the fact.

It is very important to understand that a good portrait must first be a good photograph. It is that simple. A photograph can also be the exploration of collage, mixed media – anything that works. I am interested in images that excite me, not in semantics.

Labels are inhibiting, though they are continuously used in teaching institutions, organizations that preach restrictions and rules to impressionable young minds. They teach the "best way" or "the only way," creating unyielding definitions that preclude any exploration of the future. I do not claim that my approach is the "best" or the "only" way; it is simply my way, because it is the kind of person I am. It is the way I see, think, and interpret.

We don't take photographs with our cameras, we take them with our hearts and our minds. They are a reflection of ourselves, what we are, and what we think. Every artist *is* part of his work; otherwise, the work would be nothing more than a laundry list of objects – mindless, without passion, without meaning.

I am not interested in Talmudic discussions of whether photography is art or not. That is an argument for history to decide. However, that acceptance seems to be clear already. "Artist" is a term bestowed by others, but those who call themselves "art photographers" are self-anointed, pompous, arrogant, and vain egoists. Our images should speak for themselves. I call myself a photographer.

I do feel that the better and more visually exciting we make our images, the greater is their acceptance and their use. This requires thought and experiment. The very label "stylish" surely means following what is already in style. But just what is style? Style is a result, not an aim. It is a most misunderstood word. All good art is a *result,* not a contrived attempt to draw attention by shock, schlock, or glitter.

Cézanne, who helped lead the revolution in modern art, used easily available common art materials. His subject matter? Landscapes, simple still lifes of apples and pears, objects, and people. Not very revolutionary. It was not *what* he painted but *how* he painted that mattered. It is the same for all of us working in creative mediums. It is not *what* we photograph, but *how* we photograph that matters.

Despite the acceptance and attention I received that first year in New York, the era of the 1930s and 1940s presented great difficulties for a newcomer – and even for the accepted masters – for very few could earn livings from their work. Mondrian was kept alive by the good graces of his friends. Most of the artists taught at schools, while their wives worked behind department-store counters or taught. I lost my principal client, unemployment insurance, but scraped by. However, I did make great contacts. Just before going home to Florida, summoned there by the draft board in 1942, I received my first major portrait assignment for *Harper's Bazaar.*

Returning to New York after the war in 1946, I discovered that the extensive publicity about my exhibition in Philadelphia (1945–1946) had opened up many doors for me, and in a way I started professionally at the top. My first assignment for *Life* was Eugene O'Neill (plate no. 71), and an early assignment for *Harper's Bazaar* was Igor Stravinsky (plate no. 18). *Bazaar* gave me a number of fashion assignments, but gradually we both realized it was not my forte.

Finding a suitable concept for Maestro Stravinsky was a problem. He lived in California, but I was asked to photograph him in New York. But where? A hotel suite where he was staying was only a small part of his "environment." My solution was to use the piano in a symbolic manner. I loved its strong, abstract, lyrically beautiful shape resembling a half note. This shape, counterbalanced with Stravinsky on the left, was welded together in a simple, sparse composition. For me, it reflected the composer's own music; it was a solution to express an idea. To my astonishment, the photograph was rejected with a halting excuse by Alexey Brodovitch, *Bazaar's* art director. I still don't understand it. It became my most popular photograph, reproduced and exhibited countless times around the world.

I realized that there would always be some editors, critics, and collectors who did not understand my approach. One influential curator actually described Stravinsky as a pianist in a book of his.

Over the years, the creative control of my own work has been a constant concern. Although not all clients have understood my intentions, there have been many exceptions, notably Frank Zachary, with whom I have worked since 1943 at *Portfolio, Holiday, Travel & Leisure,* and *Town & Country.* Others were Allen Hurlburt at *Look,* Charles Tudor at *Life,* and George Kirkorian, art director for promotion and advertising at the *New York Times.* A large number of the assignments they gave me are in the "Americans."

Traveling for *Life, Holiday,* and other major magazines gave me the opportunities I would not have had without such influential publications behind me. As my reputation grew, I found that doors opened on their own, all the way up to the White House. Equally important, my commissioned travels enabled me to seek out people for my personal work who otherwise would have been difficult to reach.

While photographing in Milwaukee for *Life* in 1947, I realized that I was a short distance from Taliesin East, Wisconsin, Frank Lloyd Wright's home and studio. A telephone call brought a surprise invitation to come and visit and to photograph him. Wright more than lived up to his reputation of being difficult. In the middle of the sitting, he abruptly left, saying, "I'll be back in a moment." After an hour of waiting, I went looking for him and found the master sitting on a thronelike chair, surrounded by his acolytes, who were humbly seated on the floor. He acknowledged my presence but continued talking. Knowing I had the picture I wanted (plate no. 54), I packed my equipment and loaded my car. At that point, Wright came out and sheepishly suggested we go on with the sitting. I took a couple of snaps and left.

Like so many others, I augmented my editorial work with commissions from corporate annual reports, motion-picture companies, or the subjects themselves. I knew from the beginning that I had to remain independent, operating my own studio in order to do my personal work, which occupied about half of my time and budget. Too often, the limiting requirements of an assignment gave me too little leeway, but when possible, I was able to use the opportunity to do what I wanted to do. When I. M. Pei (plate no. 53) asked me to make some portraits of him, he was principally interested in "head shots." Although I made some Interesting ones, I was intrigued by the abstract and symbolic possibilities of his office reception room and photographed him inside his receptionist's booth. Both of us were delighted with the results.

I was asked to make an illustration of Truman Capote as a collector of paperweights, an assignment I normally would have turned down. But Truman was an elusive, deteriorating character at this stage in his life, so I grabbed the opportunity to pin him down. I completed the required illustration and began my "personal" shots, aided by Truman's enthusiastic cooperation. The central air conditioning was broken, and it was unbearably hot in his apartment. Truman made himself "comfortable" nonetheless – almost embarrassingly so for my assistant and myself – but we got great shots (plate no. 99).

In addition to every state in the United States, my work has taken me on extended trips to every continent on assignments, workshops, lectures, and openings of my various exhibitions. But, as Capote might have said, "other photographs, other projects."

As assignment after assignment followed year after year, my ideas expanded and developed. Some work became too routine and repetitious, and I found myself being more selective. At the same time, the focus of my work changed because of a greatly increased interest in my photographs by museums and collectors. Most satisfying were my exhibitions and published books, giving me greater control over my work.

My travels have also increased with the lectures and openings of my exhibitions, but the trips are a delight, and they give me more opportunities to do my own work. In recent years, I also have begun to reexplore the use of my studio, opening up new avenues for myself.

Working side by side with me for over forty years, my wife, Augusta, has concentrated on the research and office details. As our two sons grew older, she was able to travel with me on all of my extensive trips. Extraordinarily knowledgeable about photography, with an instinctive eye for all the arts, she has kept me on track with her loving, penetrating critiques – as well as keeping all the famous names and associations in an earthy perspective.

When asked by the National Portrait Gallery to select one hundred photographs from fifty-three years of work for the "Americans," I naturally was delighted, but wary. I had put together eight books and countless exhibitions of my work, and I knew about the hard work and the agony of final selections. For the "Americans," there were also other considerations.

The National Portrait Gallery's mandate stipulates that the people chosen for its collection must each have made a significant contribution to our history and society. To make the selec-

tions from my work, Will Stapp, then the National Portrait Gallery's curator of photographs, and Beverly Cox, curator of exhibitions, and I began with my very first portraits.

Not all of the people I have photographed are celebrities or famous. For the most part, they are not. I *am* interested in people who are involved with life, and what they do with their lives, no matter how modest. They become part of my life and work. Although some may qualify in the future, they are not among these "Americans."

For myself, I applied the strictest measures: each photograph had to meet my highest creative standards. Unhappily, a few photographs of important people, and some personal favorites of mine, had to be reluctantly put aside. Even so, hundreds remained to choose from. Although the final decision was mine, our selections were, happily, virtually unanimous. This final selection of images for "Americans" represents a vital cross section of more than a half a century of my concepts and work.

Reviewing fifty-three years of my work has been quite an experience. It was a renewal of old friendships and acquaintances—heroes and, yes, at times villains—images of those who have shaped our lives and who have, for better or worse, changed the course of our time. I feel fortunate to have recorded even a small part of it.

<div align="right">Arnold Newman</div>

PLATES

1. Theodor Geisel (Dr. Seuss), La Jolla, California, 1985

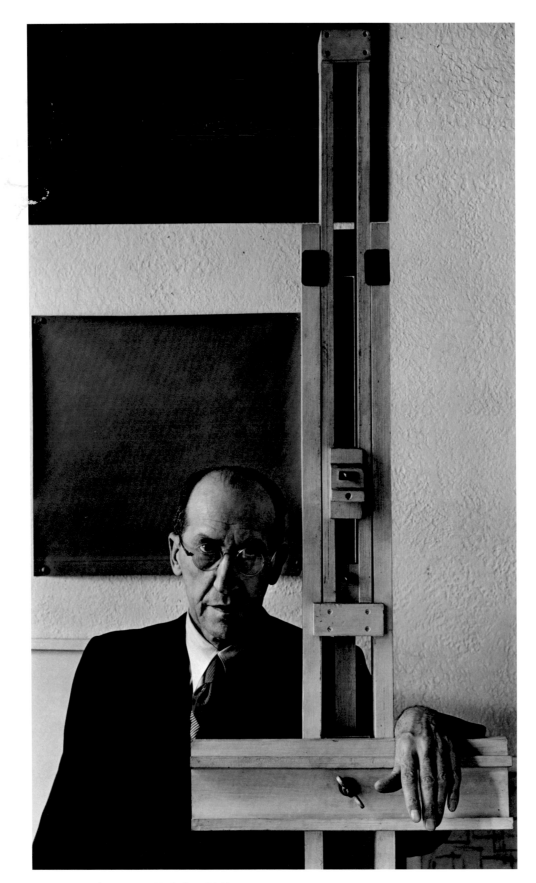

2. Piet Mondrian, New York City, 1942

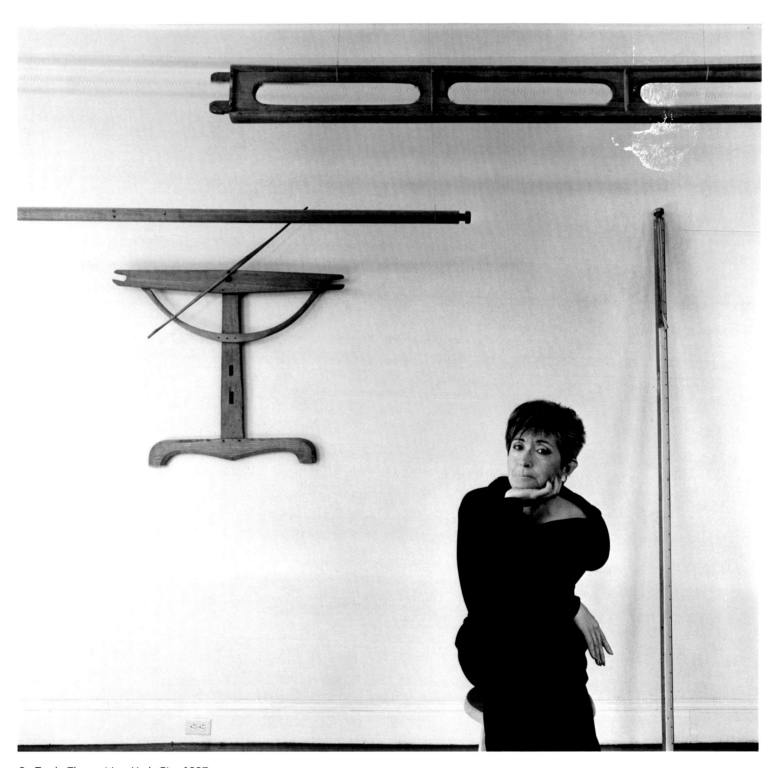

3. Twyla Tharp, New York City, 1987

4. Jacob Lawrence, Brooklyn, New York, 1959

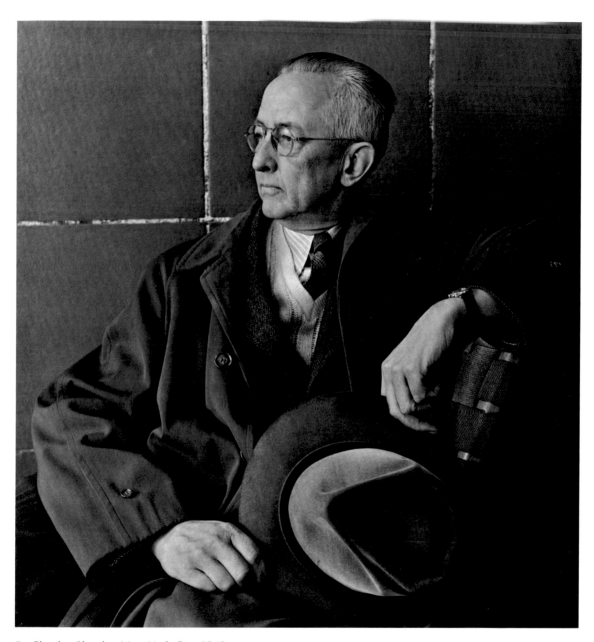

5. Charles Sheeler, New York City, 1942

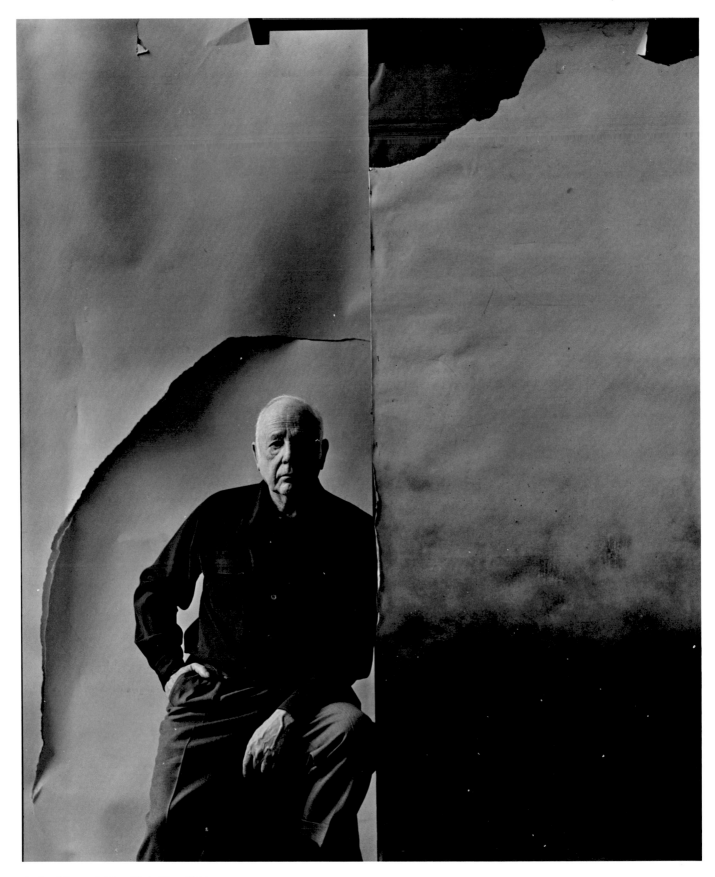

6. Paul Strand, New York City, 1966

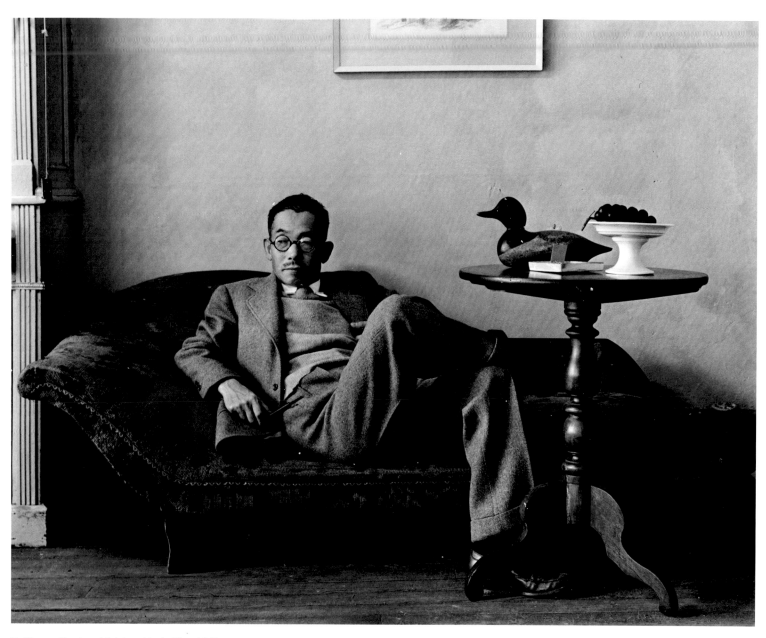

7. Yasuo Kuniyoshi, New York City, 1941

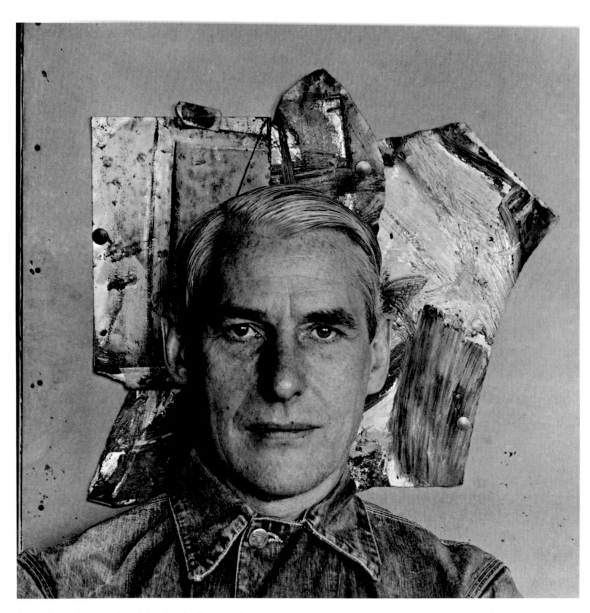

8. Willem de Kooning, New York City, 1959

9. Zero Mostel, New York City, 1962

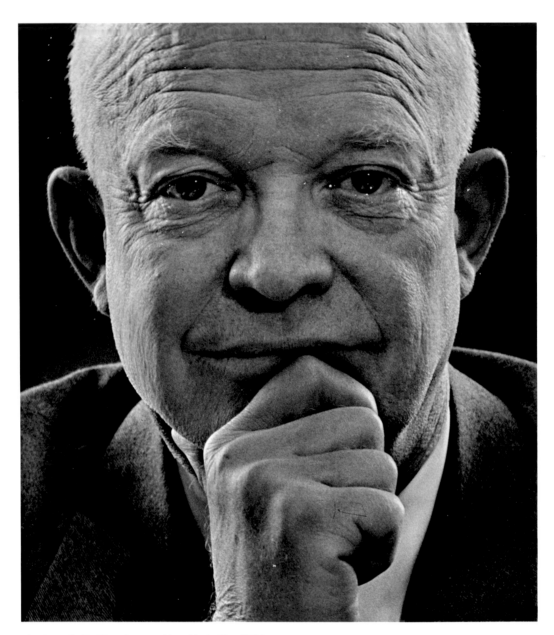

10. Dwight D. Eisenhower, New York City, 1950

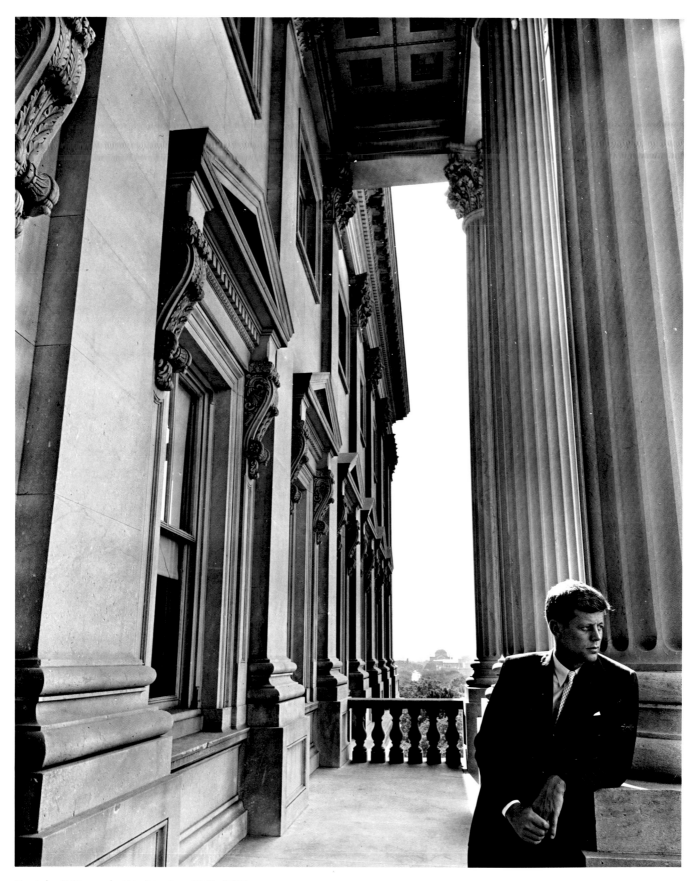

11. John F. Kennedy, Washington, D.C., 1953

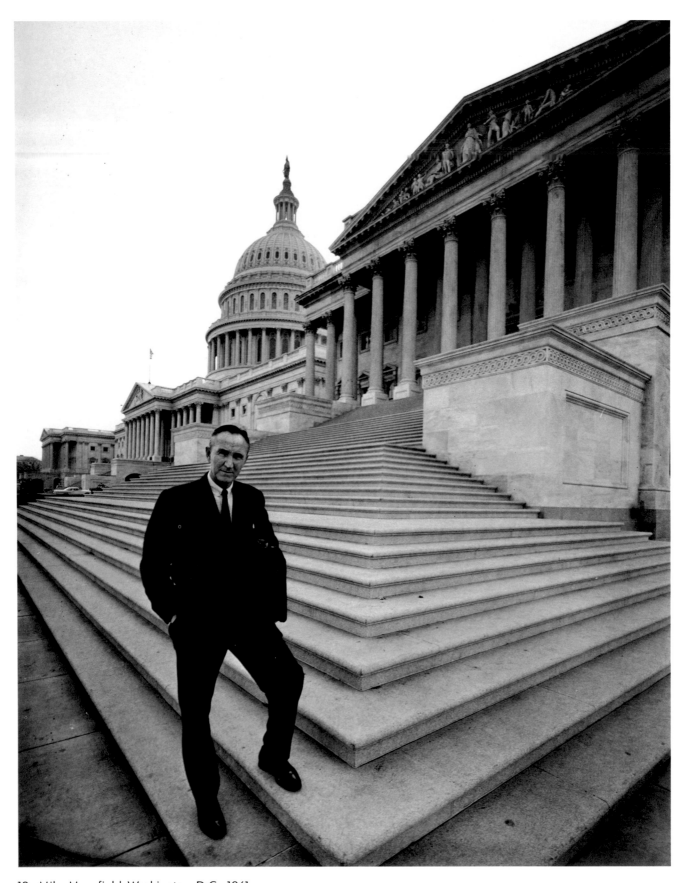

12. Mike Mansfield, Washington, D.C., 1961

13. Wayne Morse, Washington, D.C., 1953

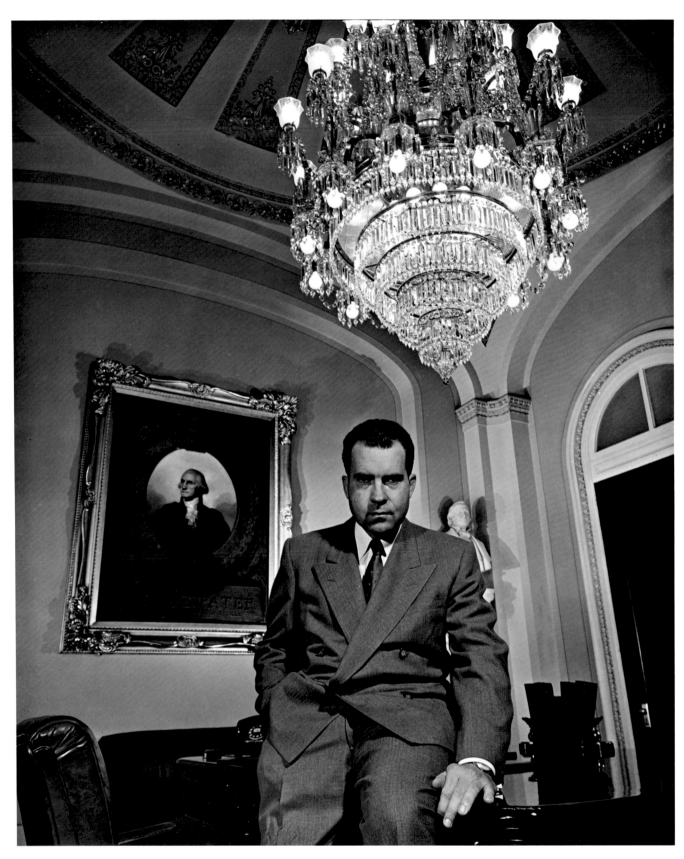

14. Richard M. Nixon, Washington, D.C., 1953

15. Joseph McCarthy, Washington, D.C., 1953

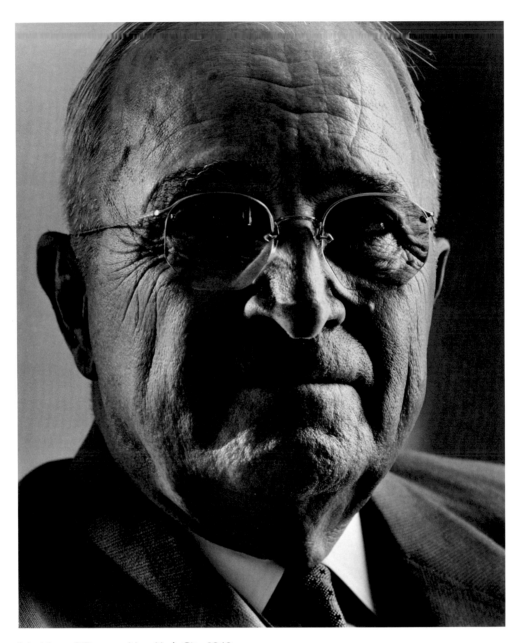

16. Harry S Truman, New York City, 1960

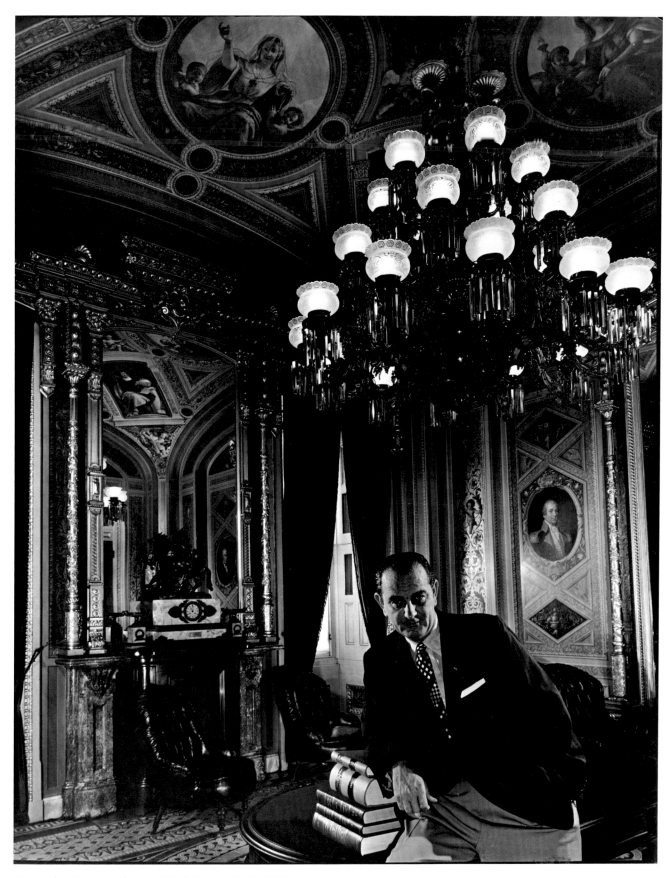

17. Lyndon Baines Johnson, Washington, D.C., 1953

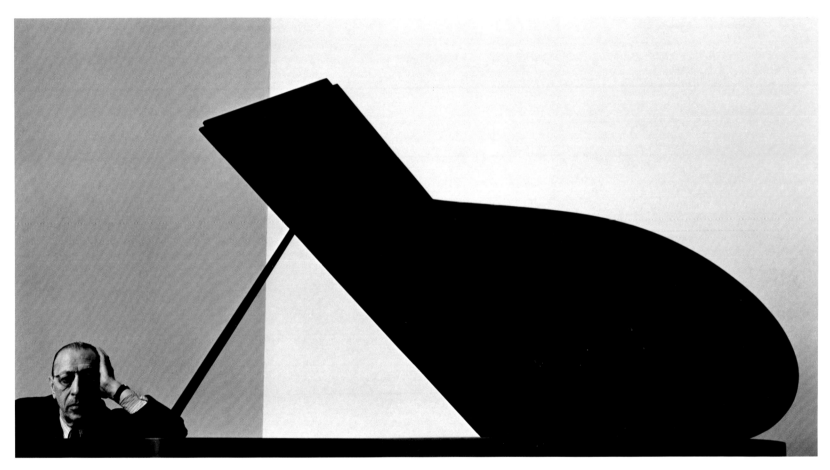

18. Igor Stravinsky, New York City, 1946

19. Martha Graham, New York City, 1961

20. Aaron Copland, Ossining, New York, 1959

21. Leonard Bernstein, New York City, 1968

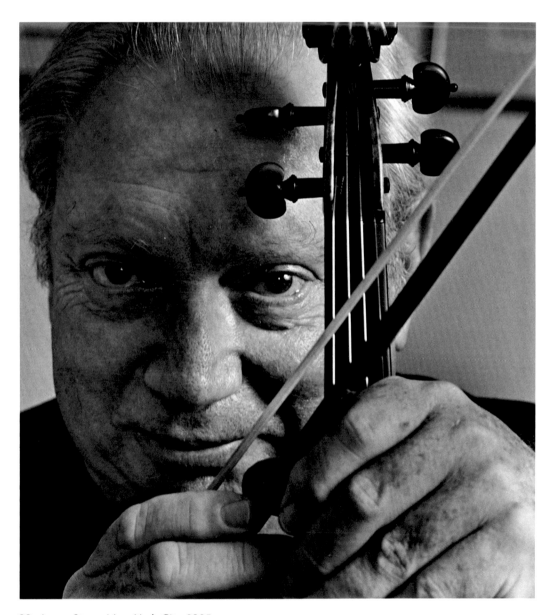

22. Isaac Stern, New York City, 1985

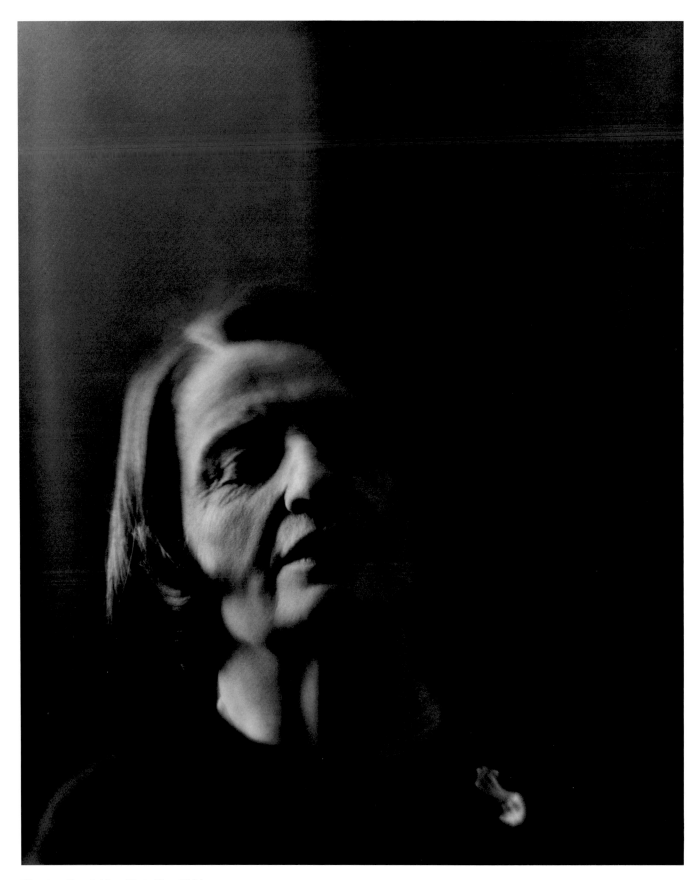

23. Ayn Rand, New York City, 1964

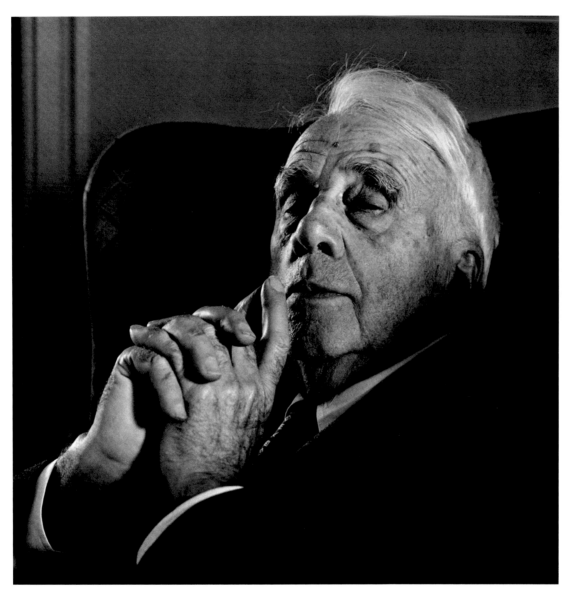

24. Robert Frost, New York City, 1956

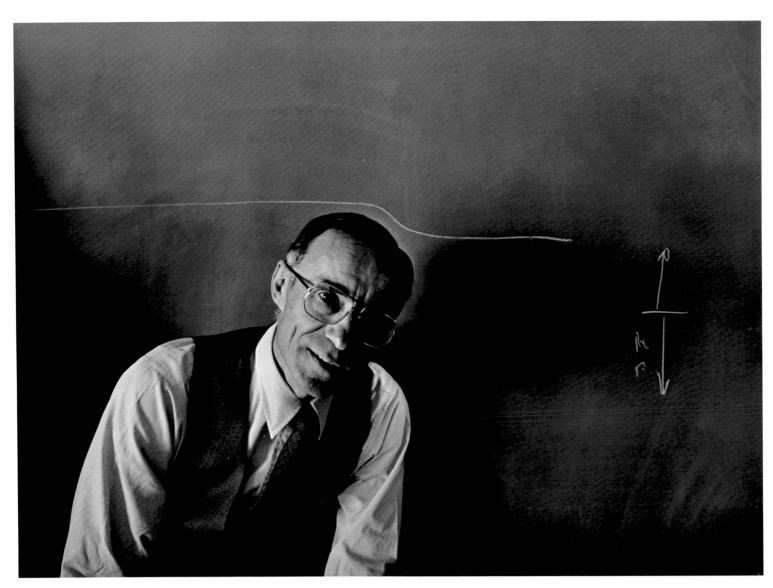

25. Arno Penzias, Murray Hill, New Jersey, 1985

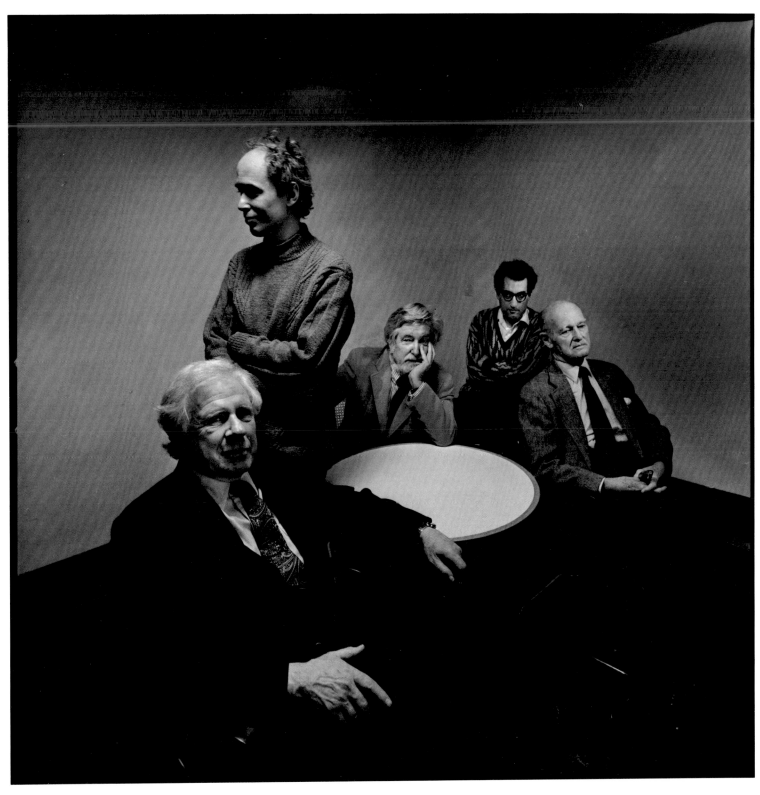

26. Fellows of the Institute for Advanced Study, Princeton, New Jersey, 1988
 (see page 144 for identifications)

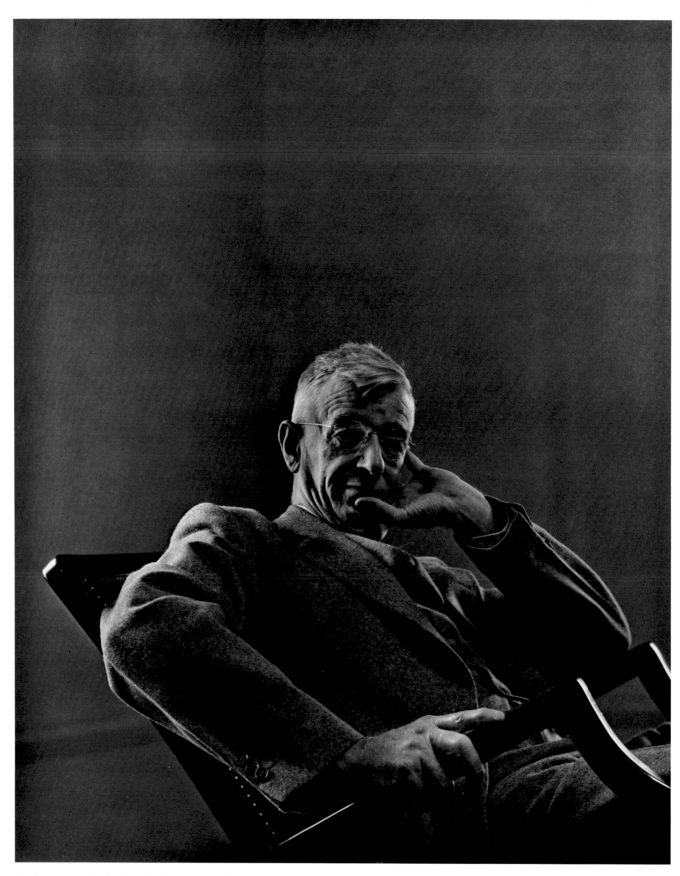

27. Vannevar Bush, Cambridge, Massachusetts, 1949

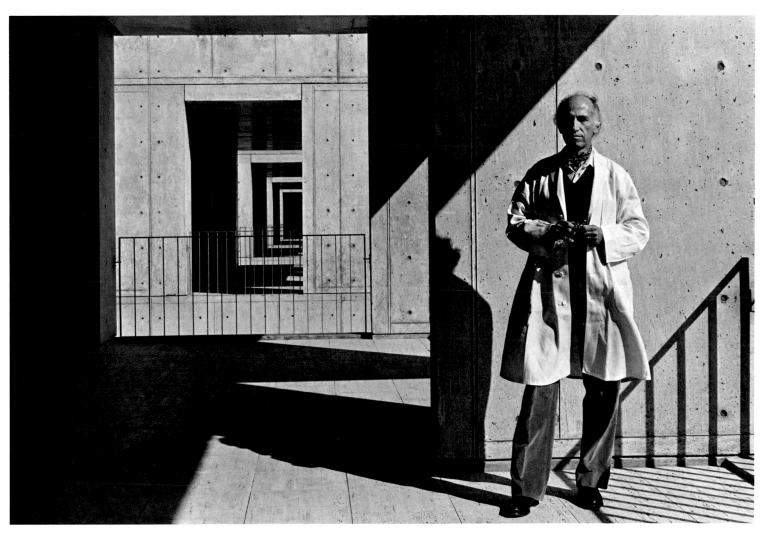

28. Jonas Salk, La Jolla, California, 1975

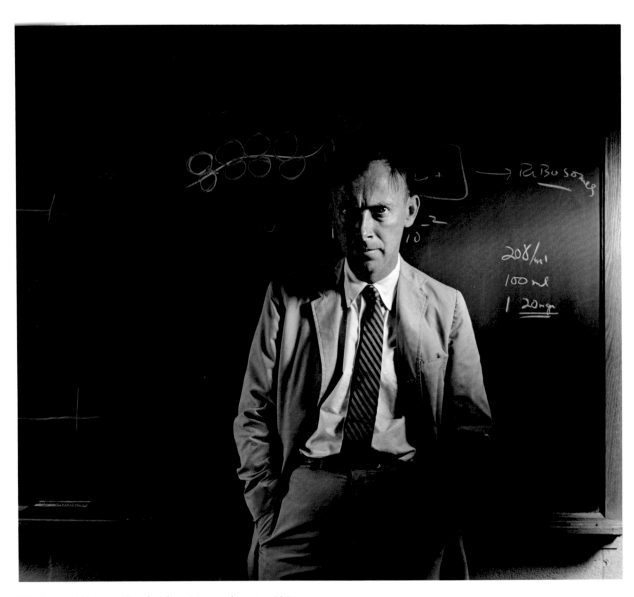

29. James Watson, Cambridge, Massachusetts, 1964

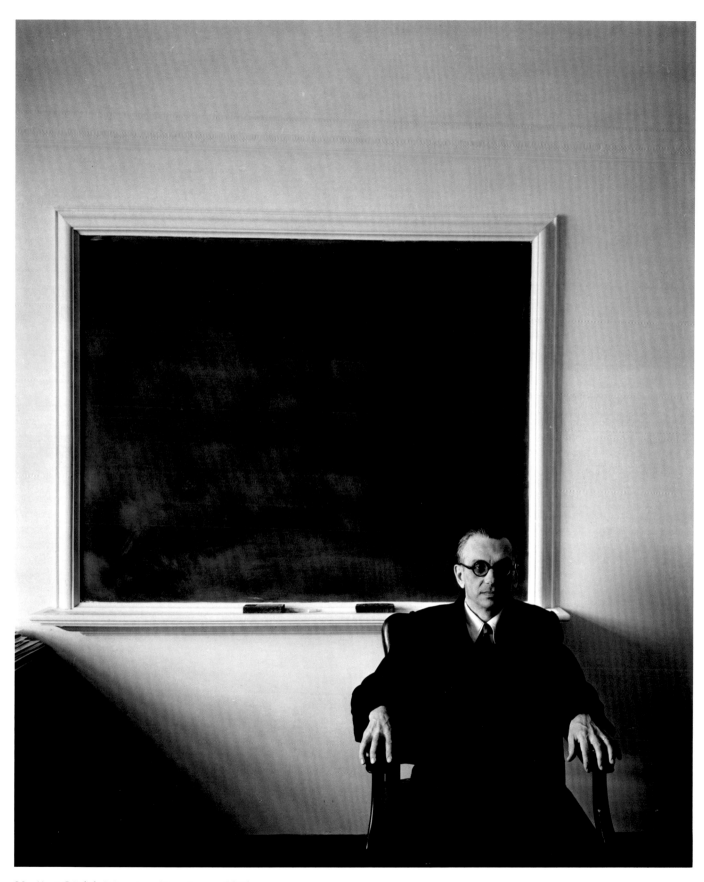

30. Kurt Gödel, Princeton, New Jersey, 1956

31. Eleanor Roosevelt, New York City, 1962

32. Adlai Stevenson, New York City, 1962

33. Robert Moses, New York City, 1959

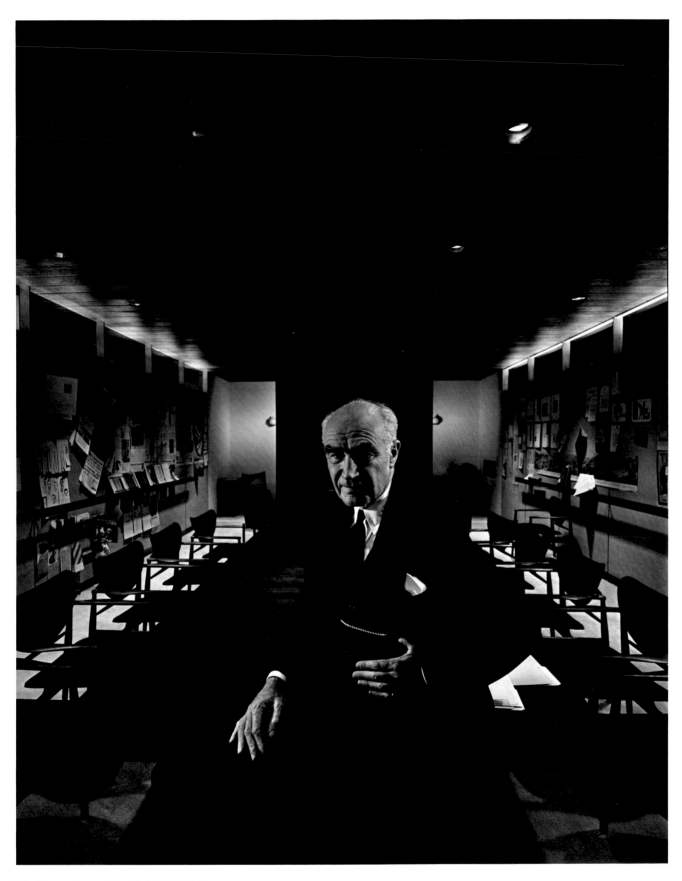

34. Henry Luce, New York City, 1962

35. Walter F. George, Vienna, Georgia, 1951

36. Joseph Welch, Boston, 1957

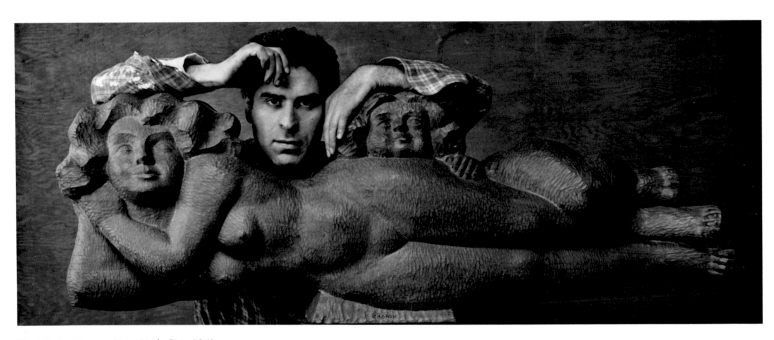

37. Chaim Gross, New York City, 1941

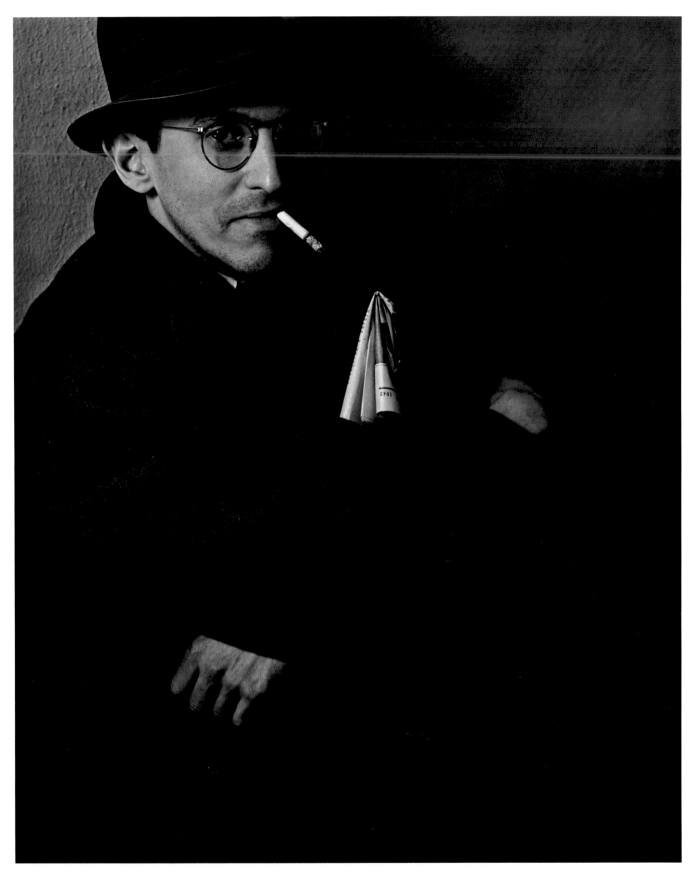

38. Jack Levine, New York City, 1942

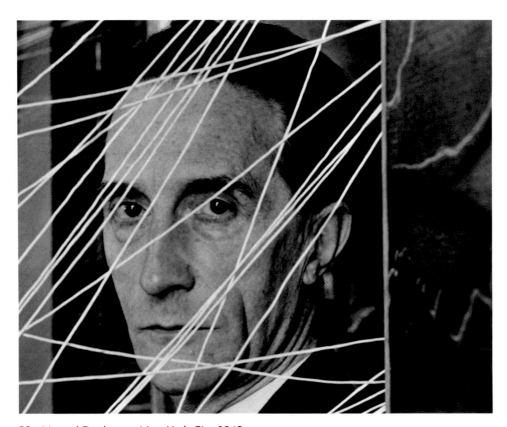

39. Marcel Duchamp, New York City, 1942

40. Man Ray, Los Angeles, 1948

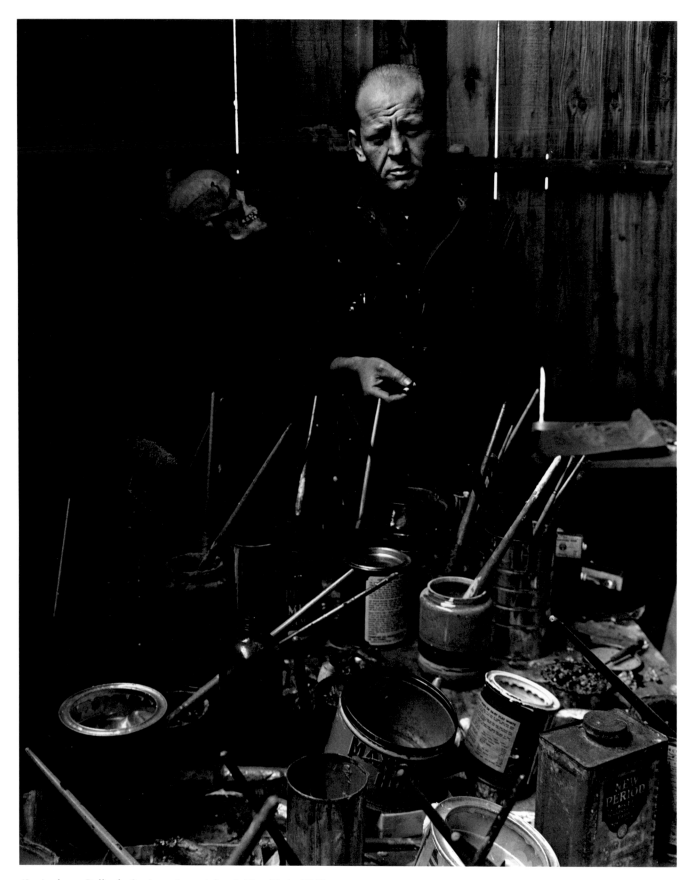

41. Jackson Pollock, Springs, Long Island, New York, 1949

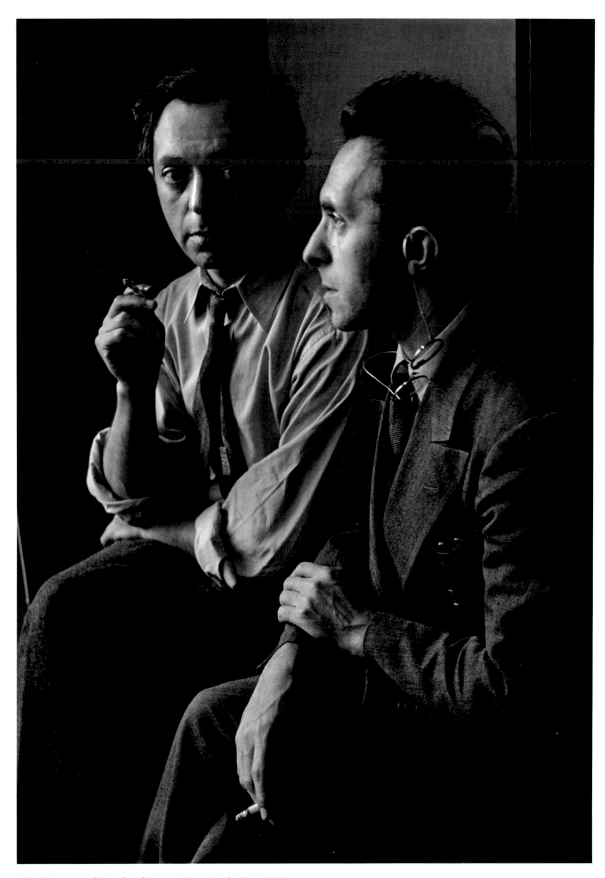

42. Moses and Raphael Soyer, New York City, 1942

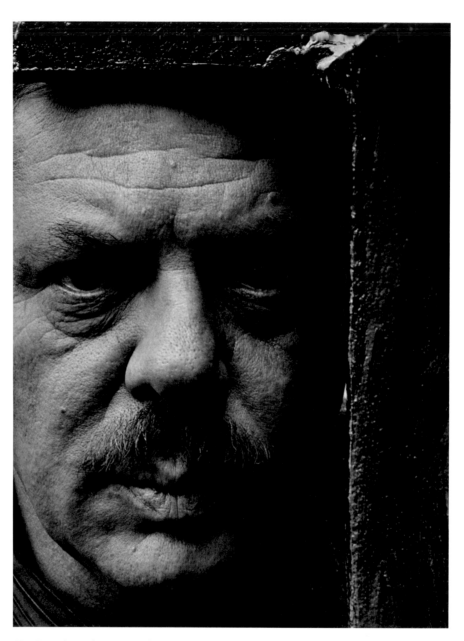

43. David Smith, New York City, 1957

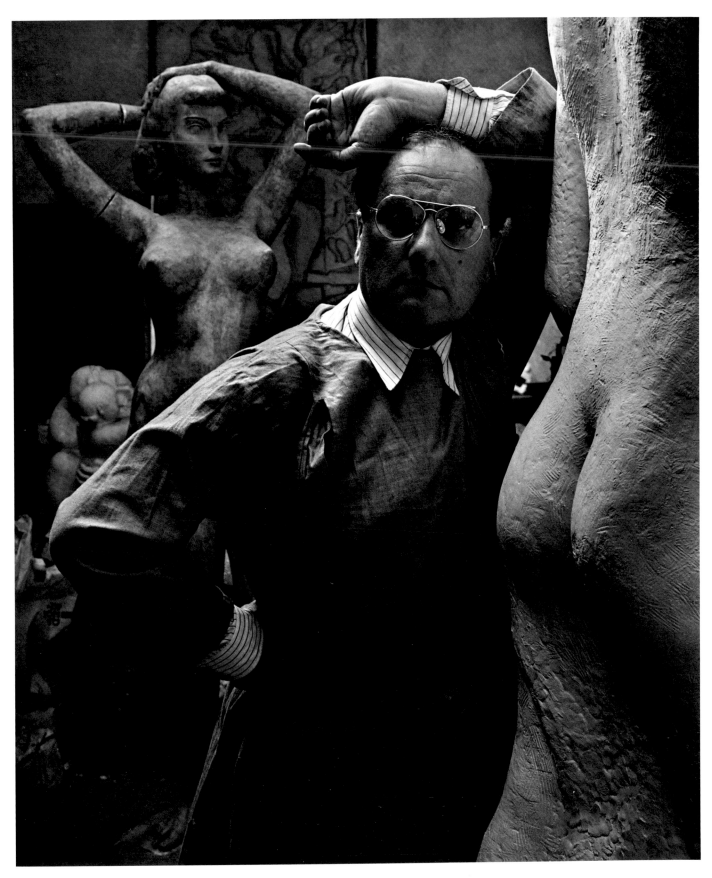

44. William Zorach, Brooklyn, New York, 1943

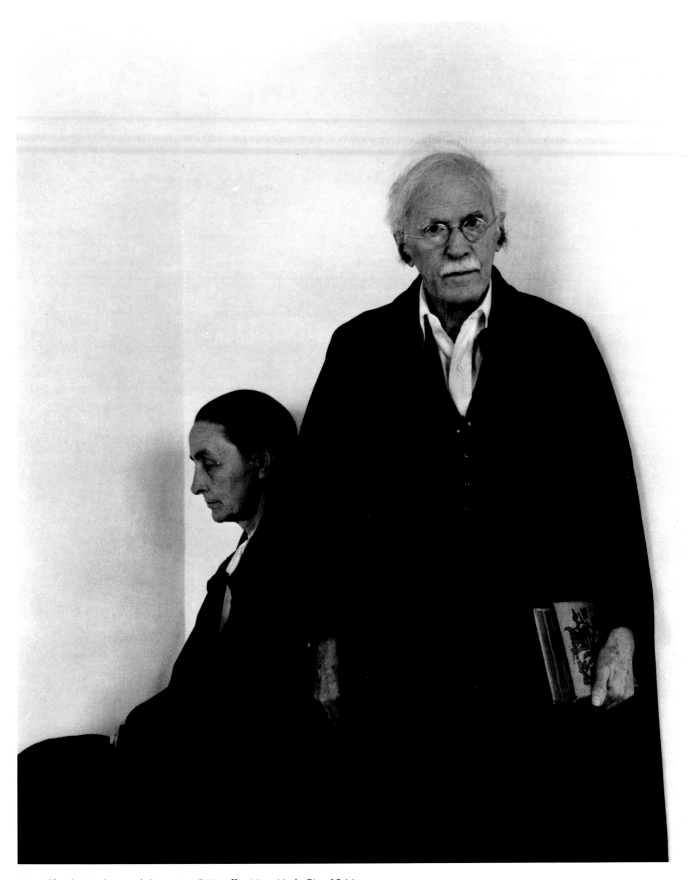

45. Alfred Stieglitz and Georgia O'Keeffe, New York City, 1944

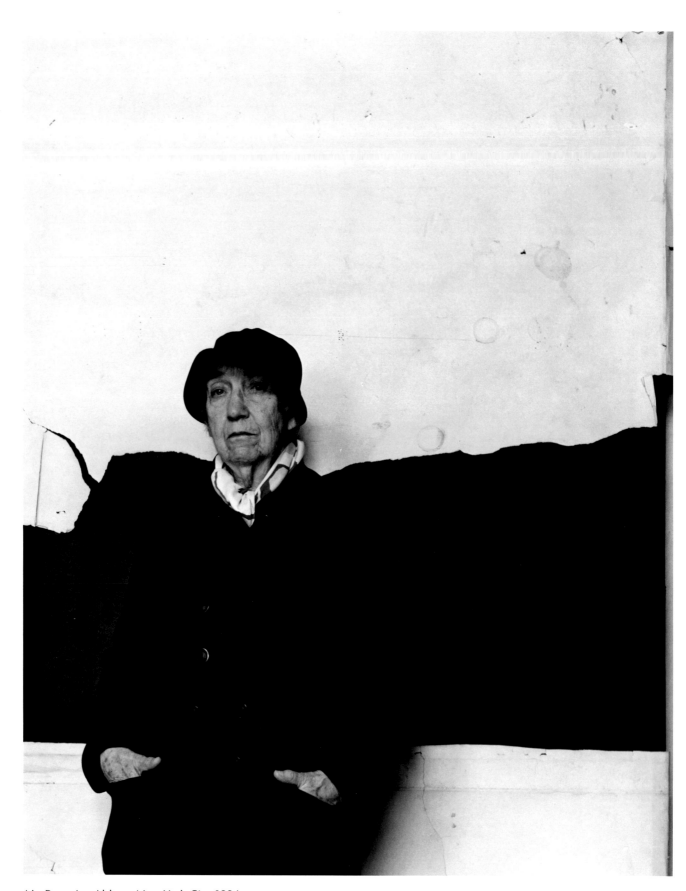

46. Berenice Abbott, New York City, 1986

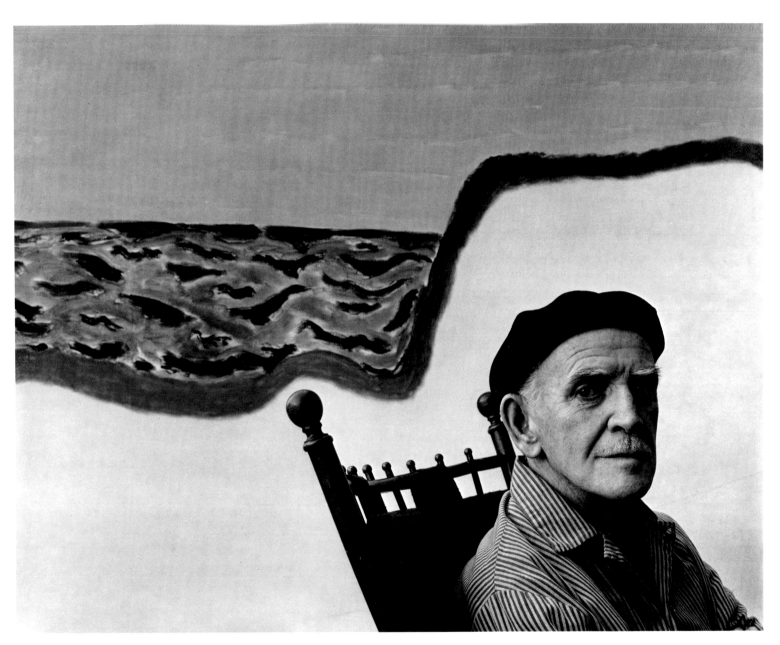

47. Milton Avery, New York City, 1961

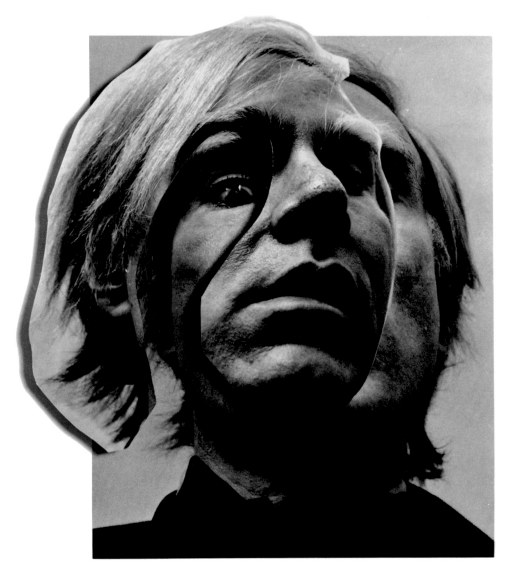

48. Andy Warhol, New York City, 1973

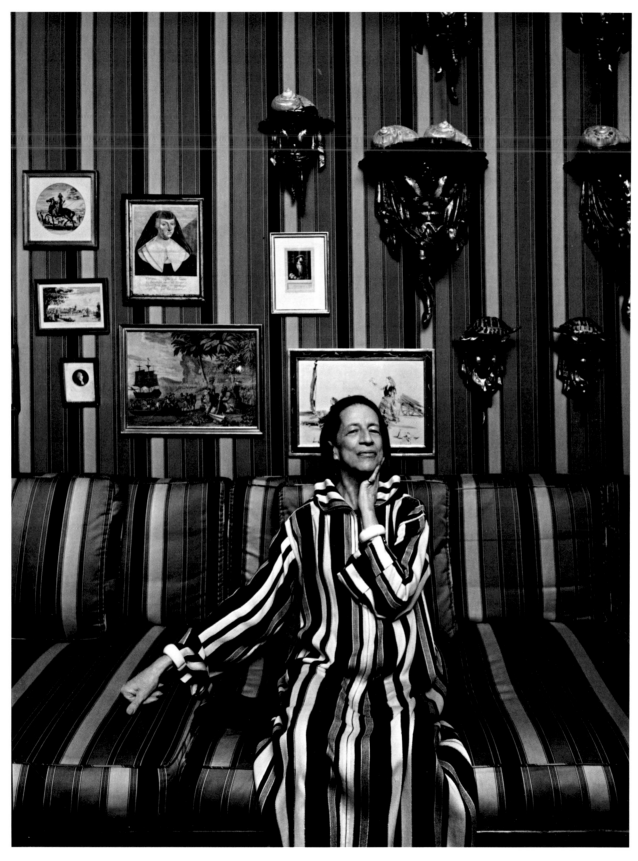

49. Diana Vreeland, New York City, 1974

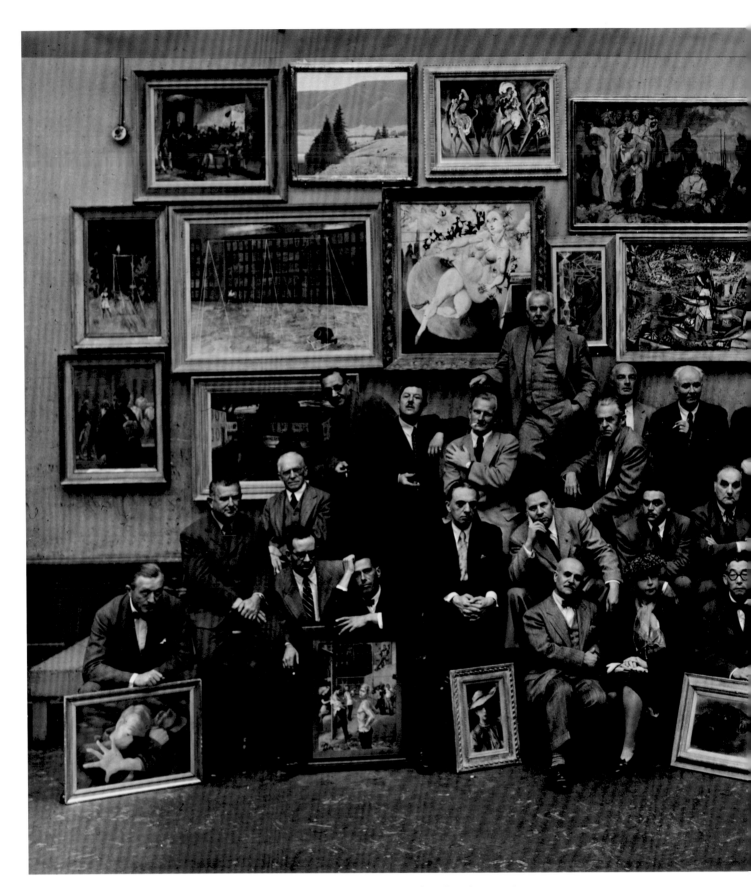

50. Alumni, Art Students League, New York City, 1950 (see pages 137–138 for identifications)

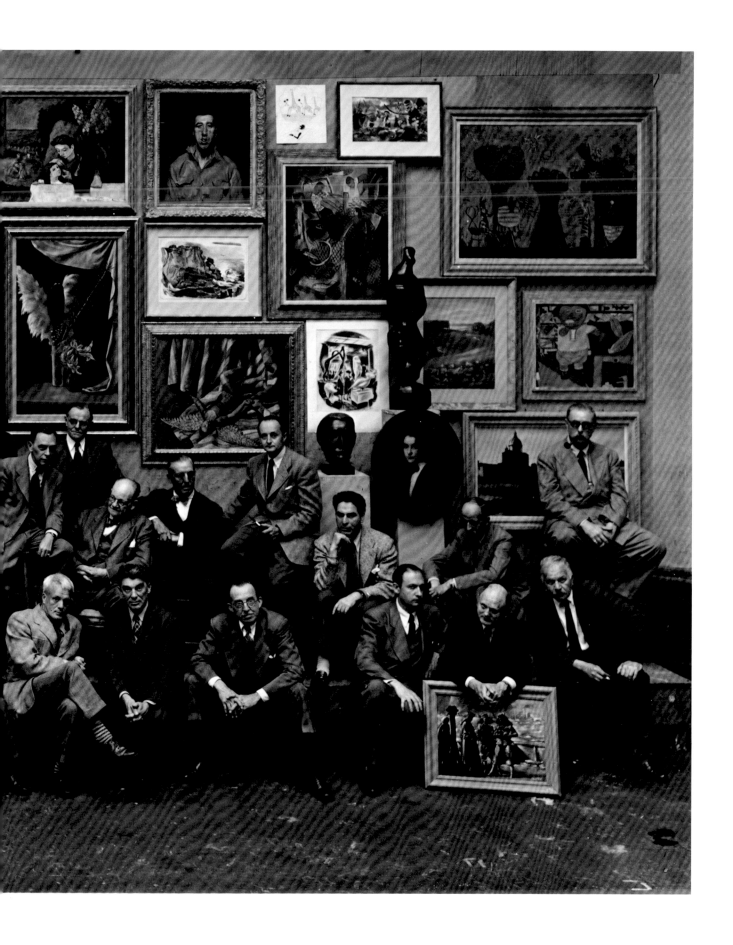

51. Barnett Newman, New York City, 1970

52. Isamu Noguchi, New York City, 1947

53. I. M. Pei, New York City, 1967

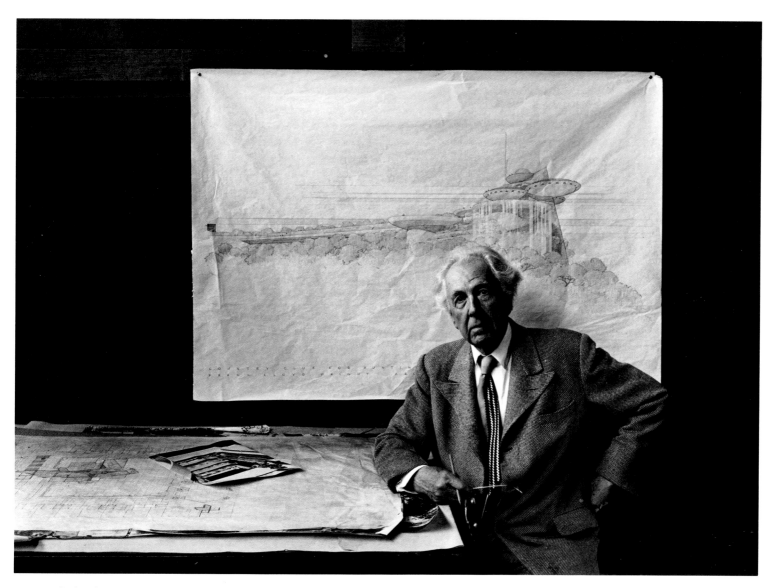

54. Frank Lloyd Wright, Taliesin East, Wisconsin, 1947

55. Larry Rivers, Southampton, New York, 1975

56. Louise Nevelson, New York City, 1972

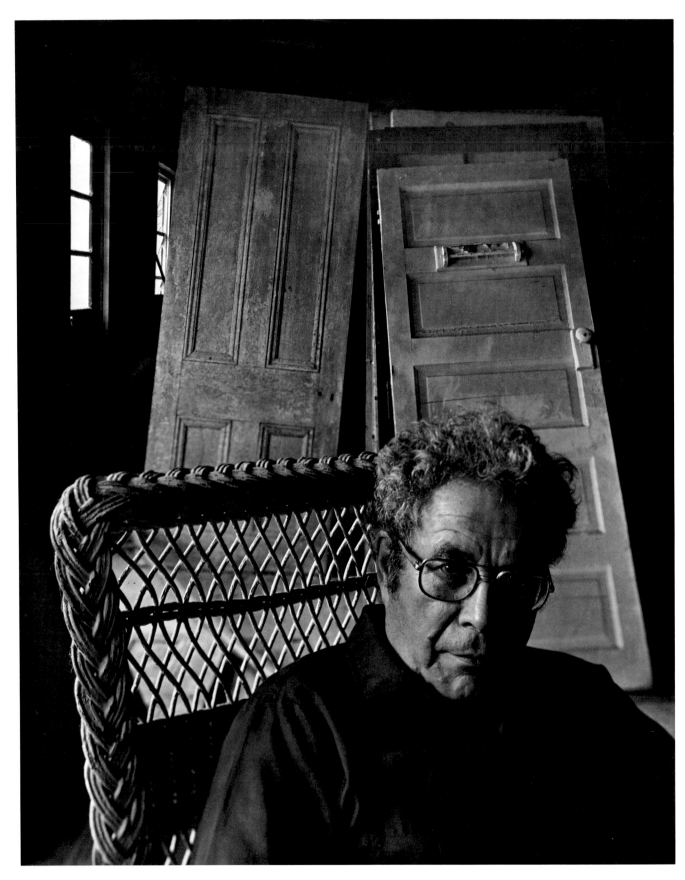

57. George Segal, New Jersey, 1985

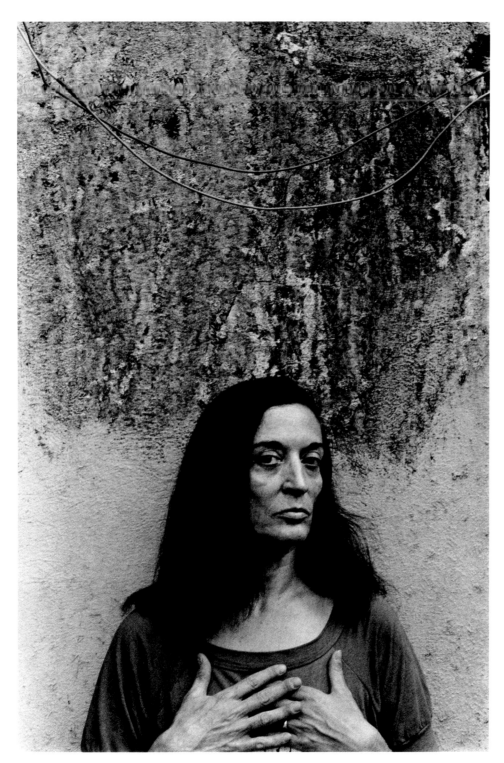

58. Marisol, New Jersey, 1985

59. Andrew Wyeth, Chadds Ford, Pennsylvania, 1976

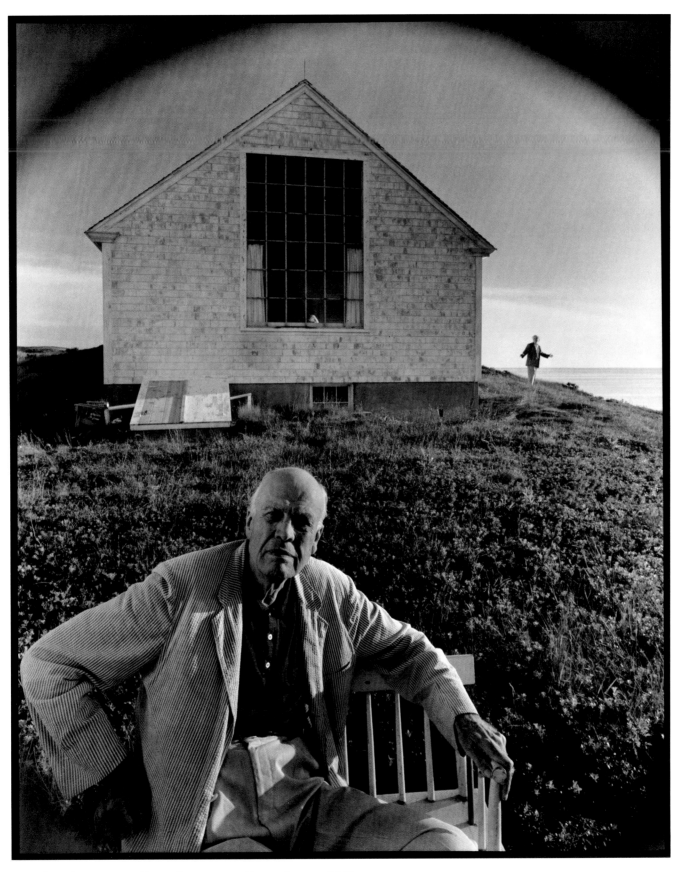

60. Edward Hopper and his wife, Jo, Truro, Massachusetts, 1960

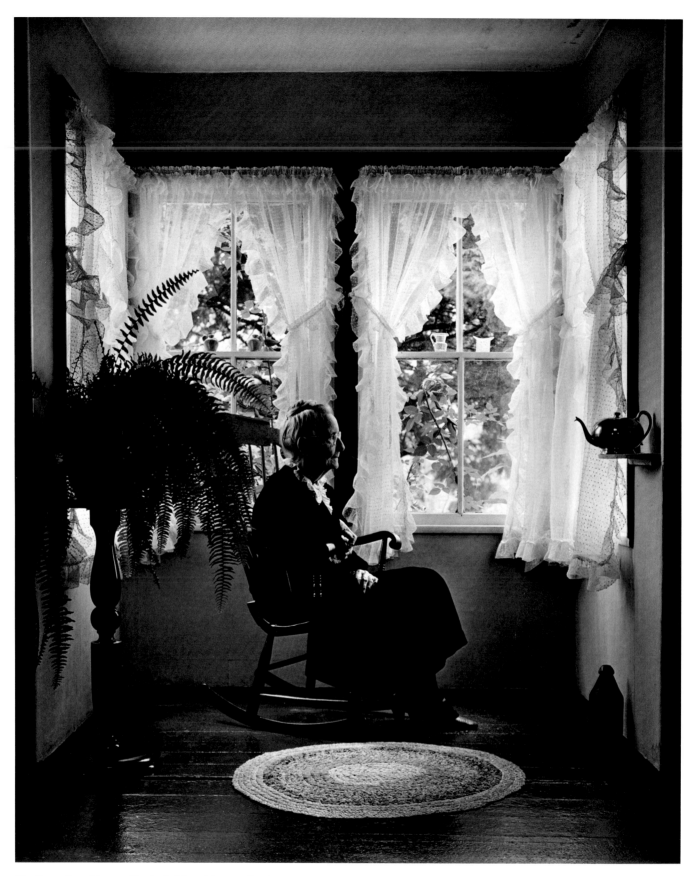

61. Grandma Moses, Eagle Bridge, New York, 1949

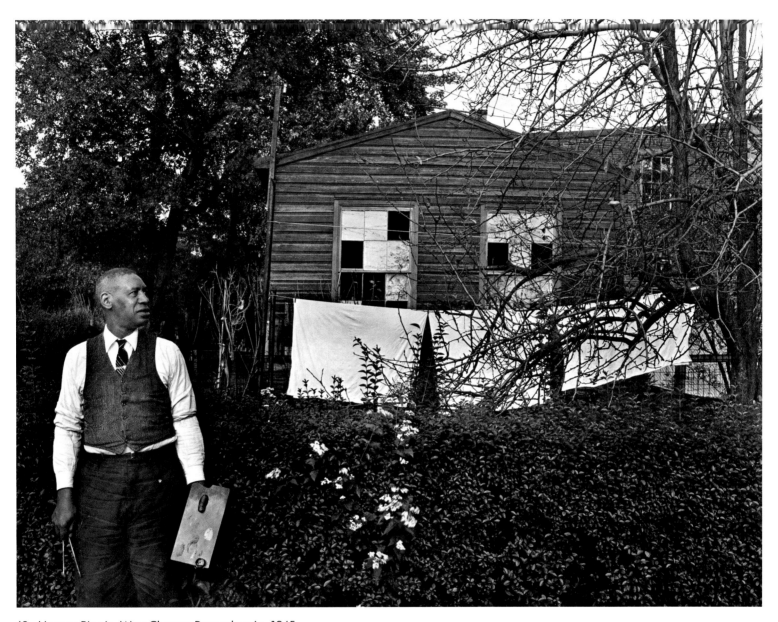

62. Horace Pippin, West Chester, Pennsylvania, 1945

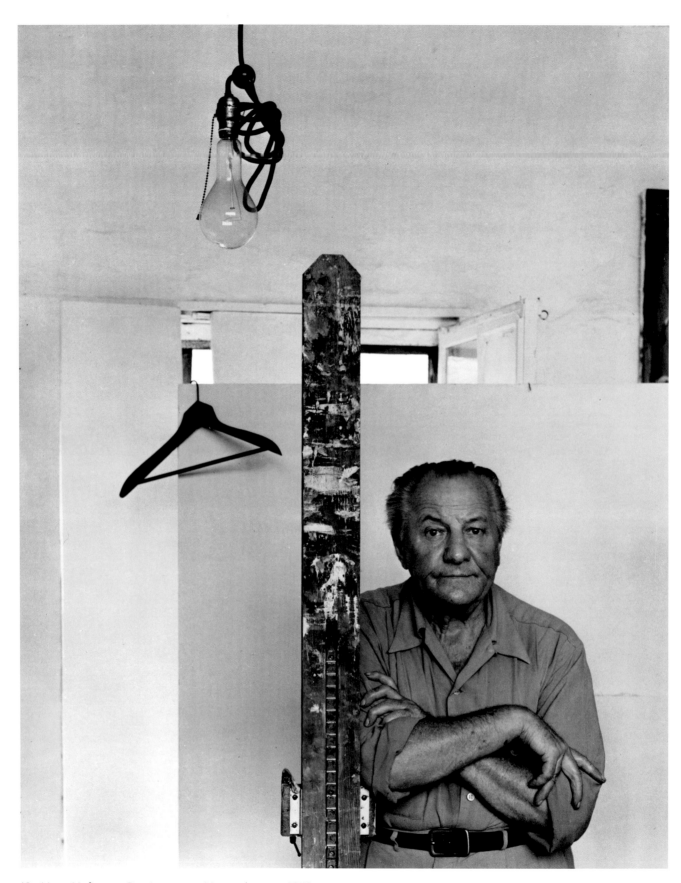

63. Hans Hofmann, Provincetown, Massachusetts, 1952

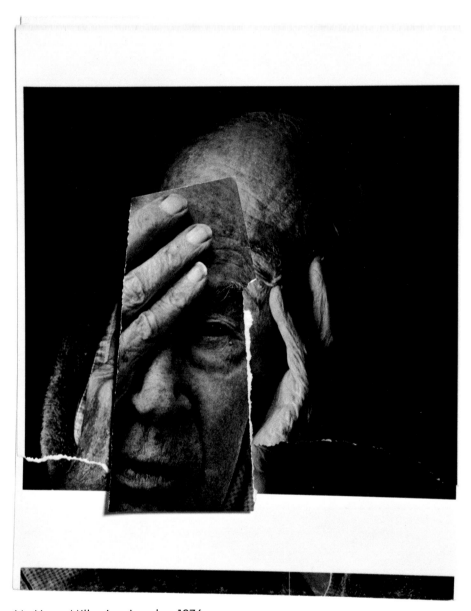

64. Henry Miller, Los Angeles, 1976

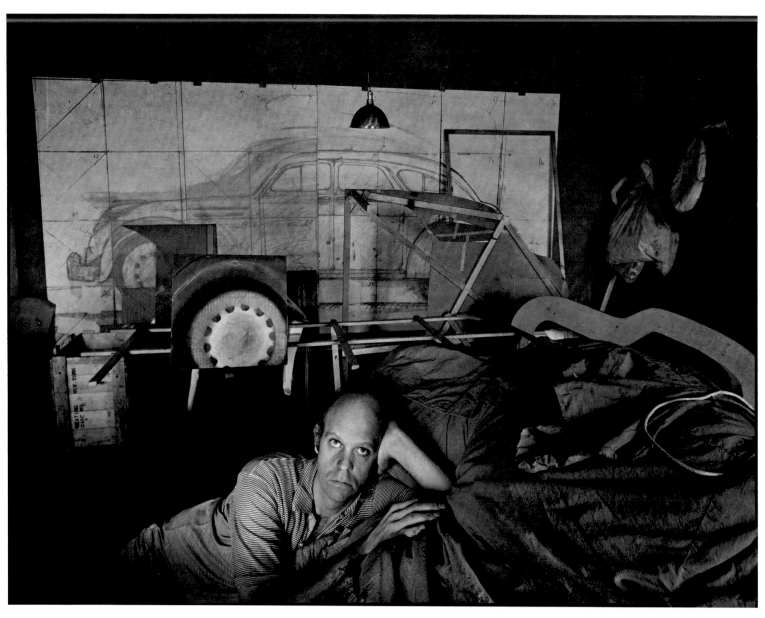

65. Claes Oldenburg, New York City, 1967

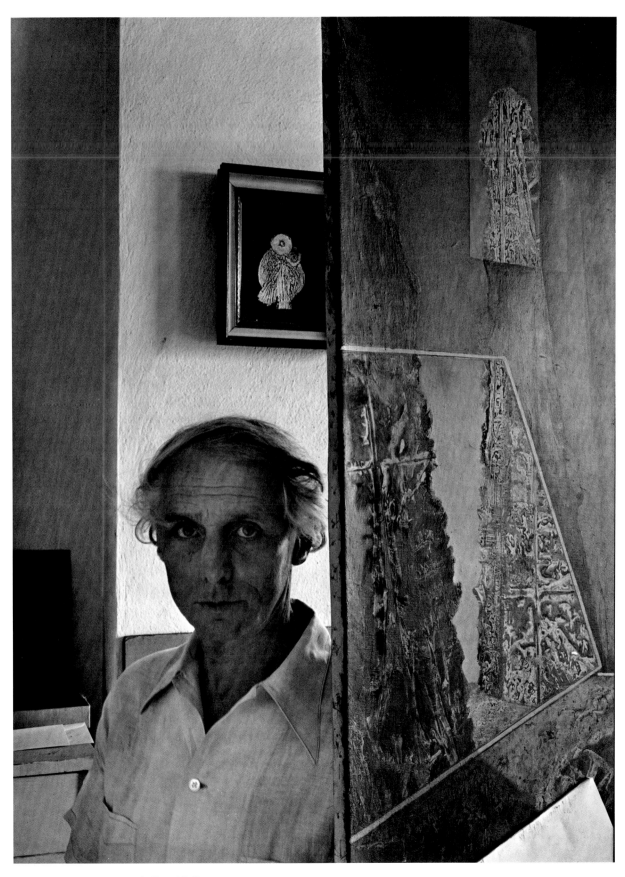

66. Max Ernst, New York City, 1942

67. Frederick Kiesler, New York City, 1962

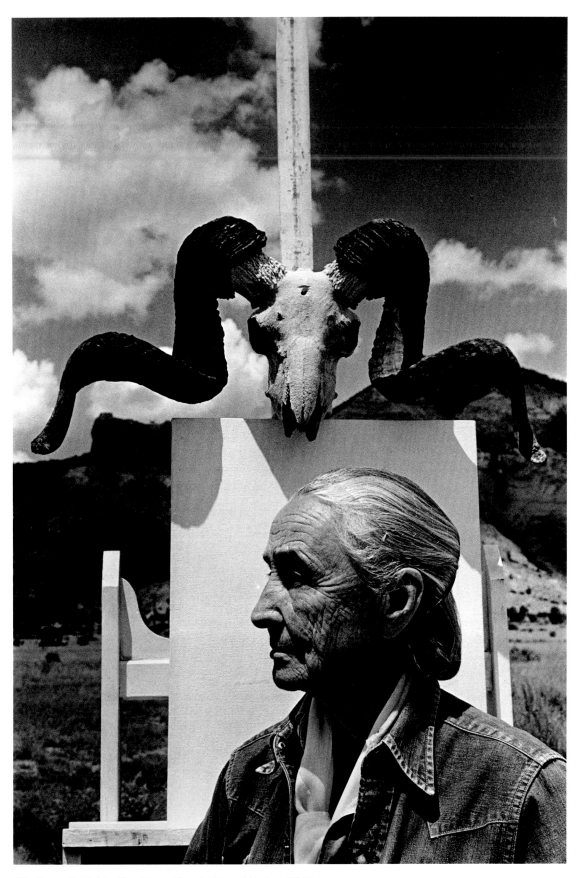

68. Georgia O'Keeffe, Ghost Ranch, New Mexico, 1968

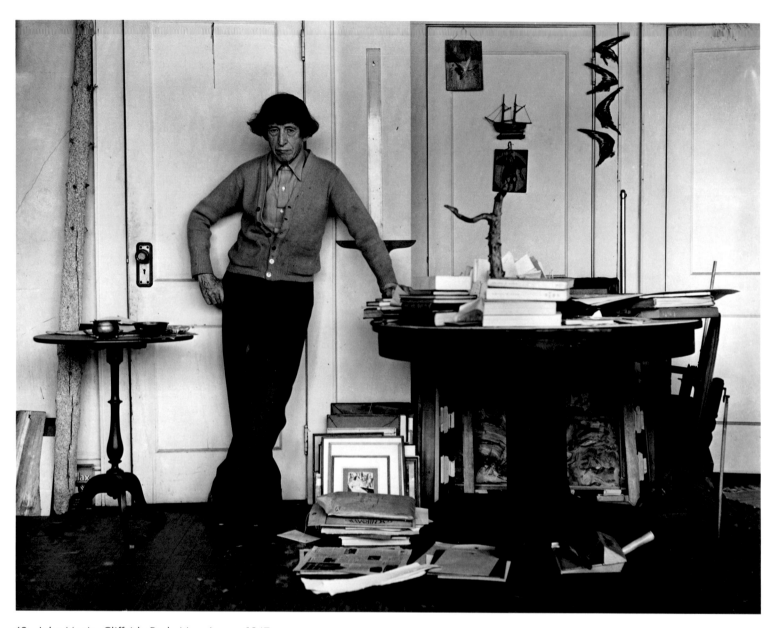

69. John Marin, Cliffside Park, New Jersey, 1947

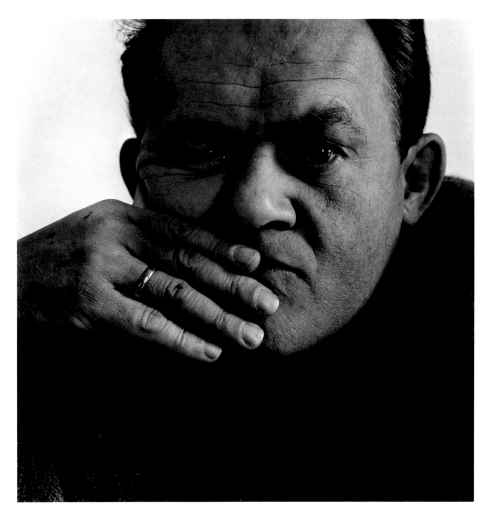

70. James Jones, Paris, France, 1961

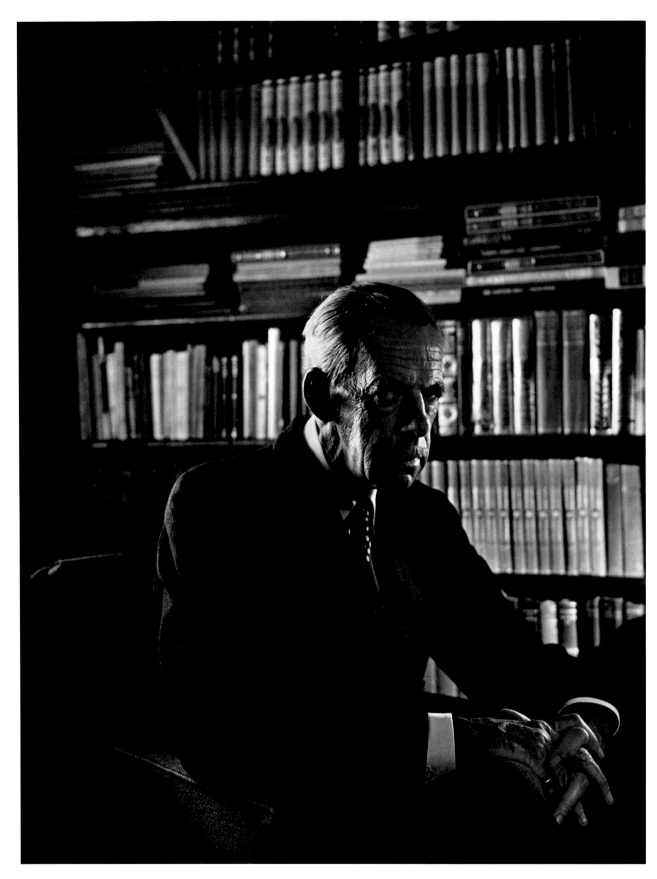

71. Eugene O'Neill, New York City, 1946

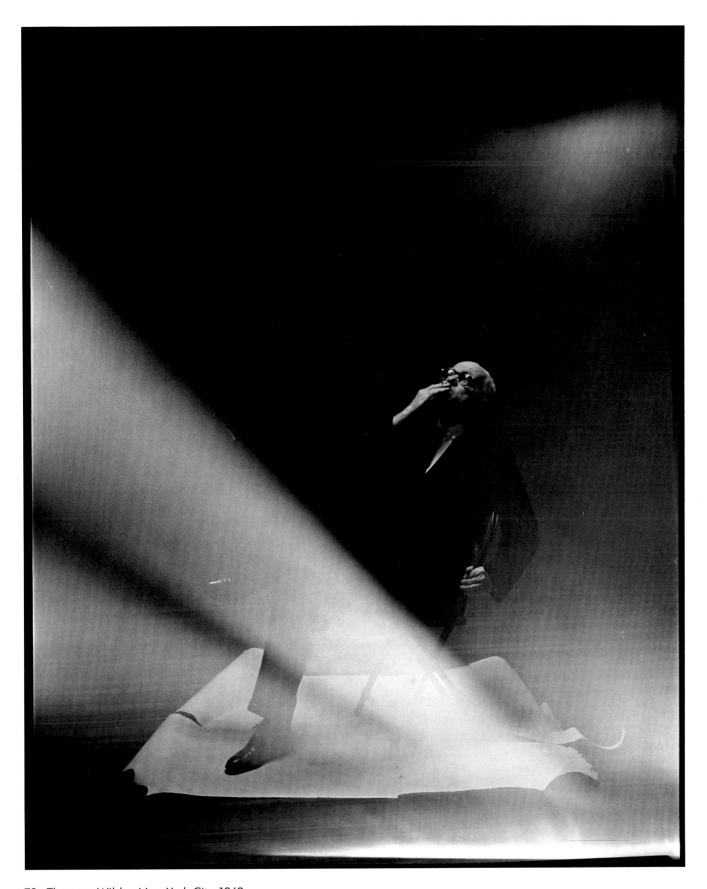

72. Thornton Wilder, New York City, 1962

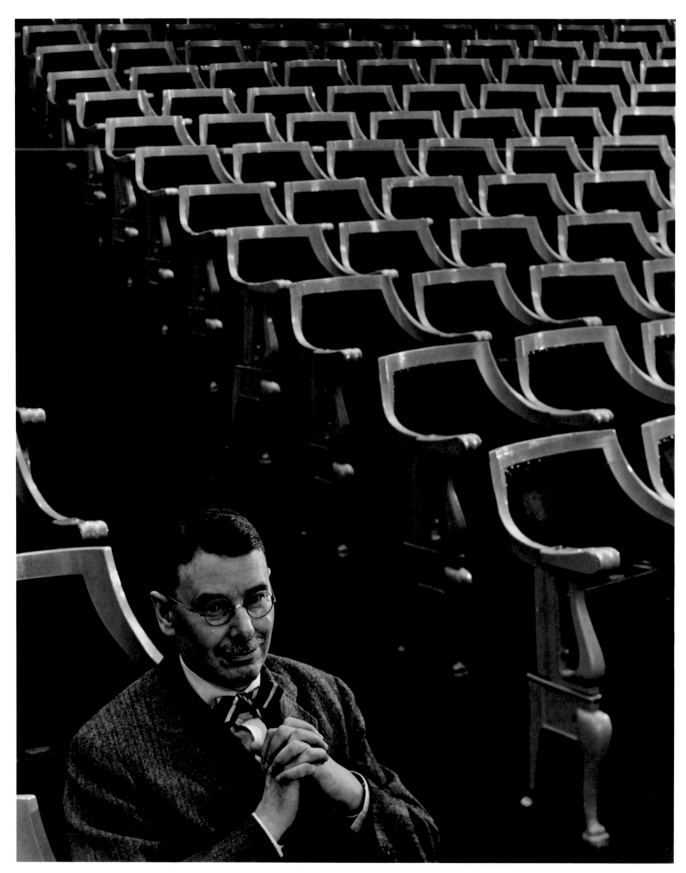

73. Brooks Atkinson, New York City, 1951

74. Gypsy Rose Lee, New York City, 1945

75. Jimmy Van Heusen and Sammy Cahn, Palm Springs, California, 1963

76. Ron Carter, New York City, 1977

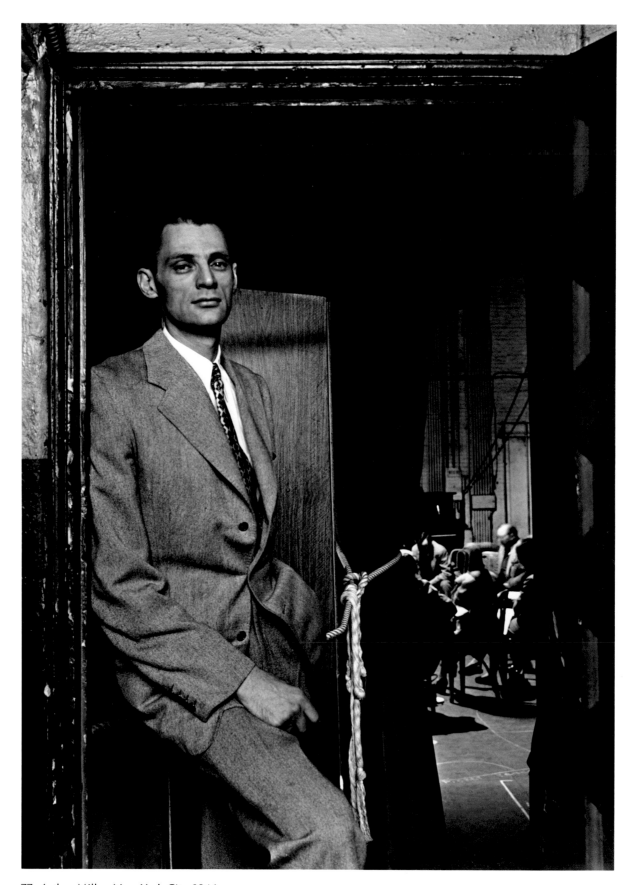

77. Arthur Miller, New York City, 1946

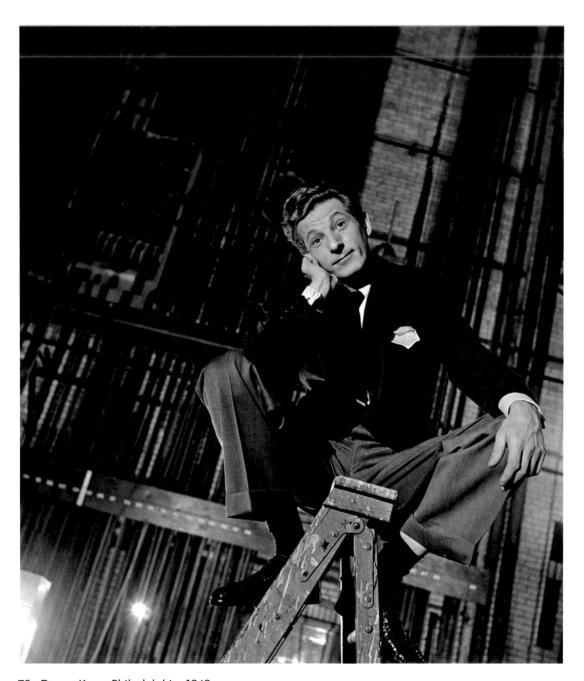

78. Danny Kaye, Philadelphia, 1949

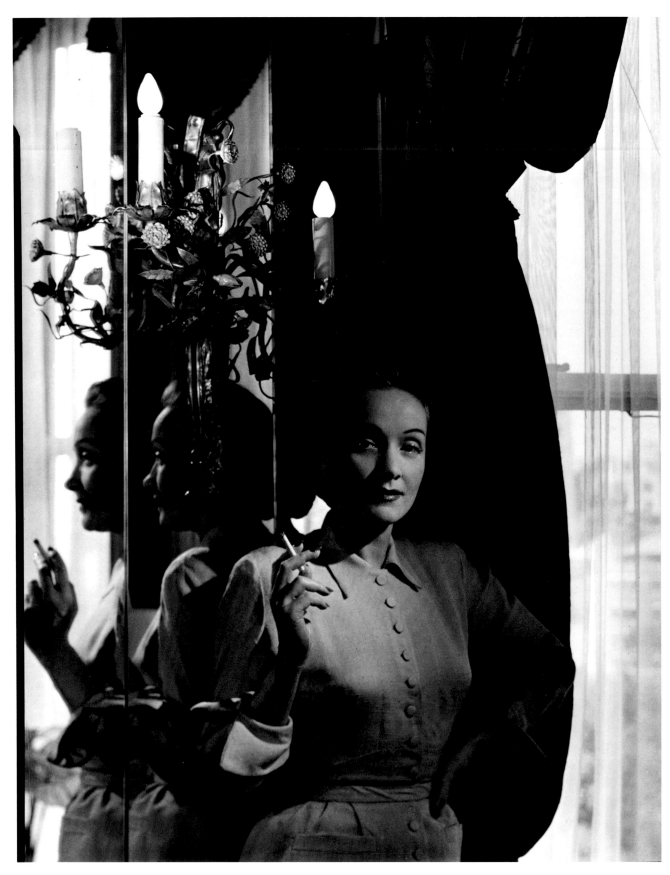

79. Marlene Dietrich, New York City, 1948

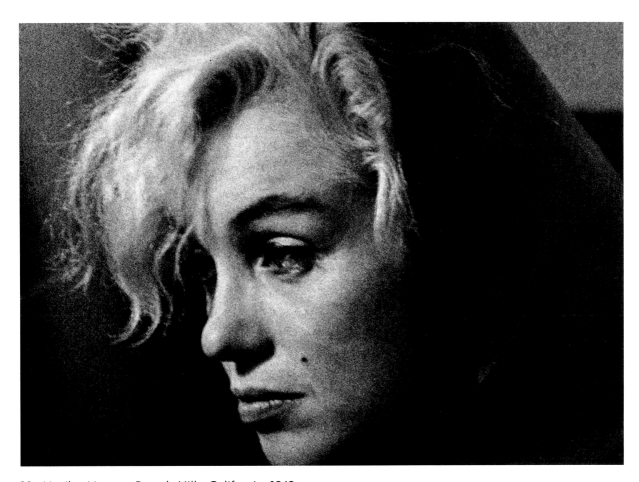

80. Marilyn Monroe, Beverly Hills, California, 1962

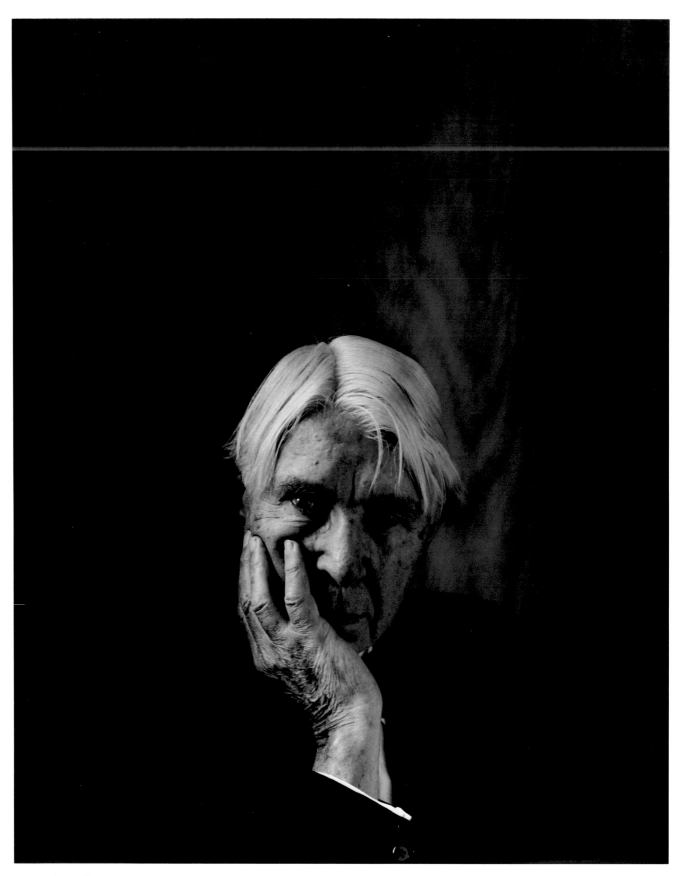

81. Carl Sandburg, New York City, 1955

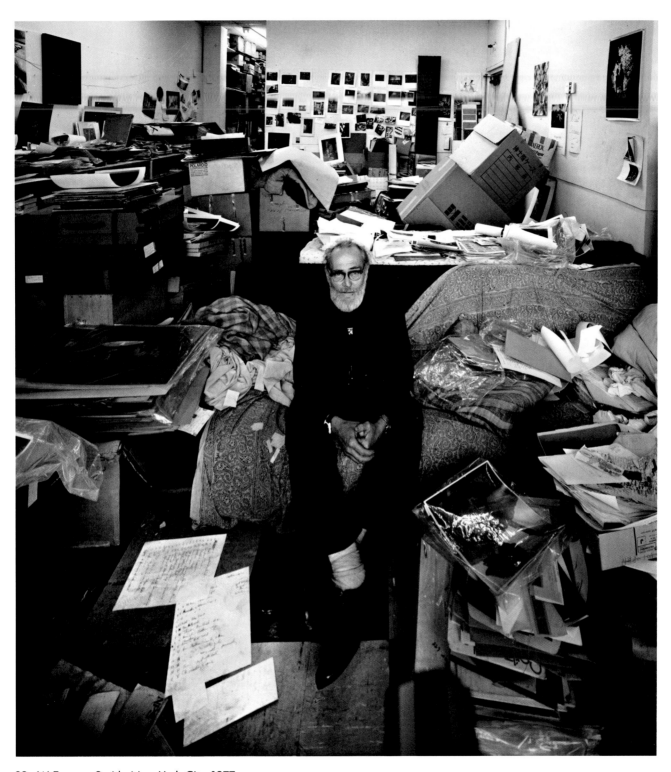

82. W. Eugene Smith, New York City, 1977

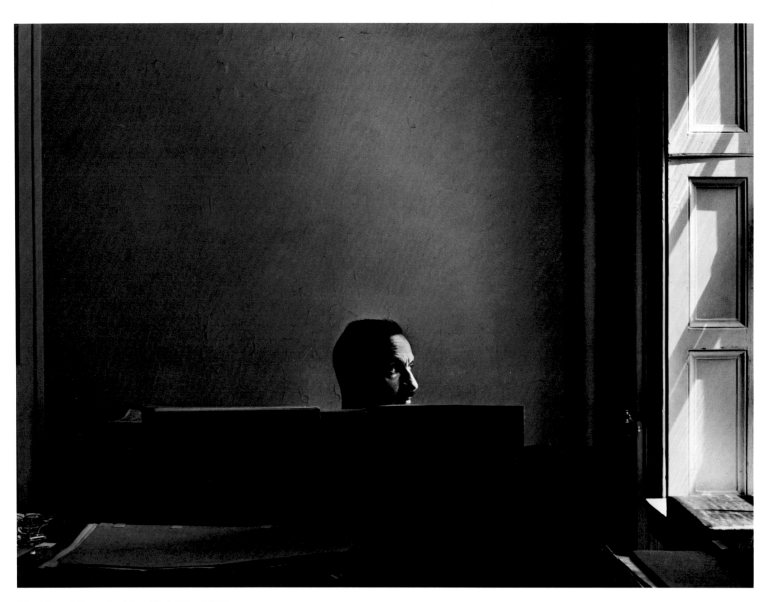

83. Marc Blitzstein, New York City, 1945

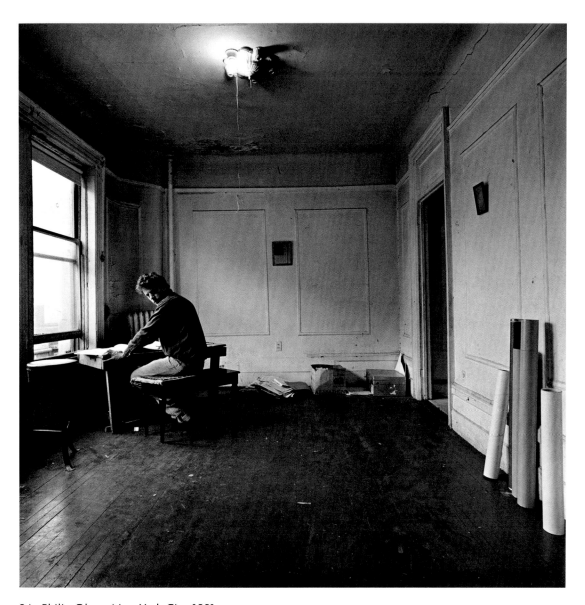

84. Philip Glass, New York City, 1981

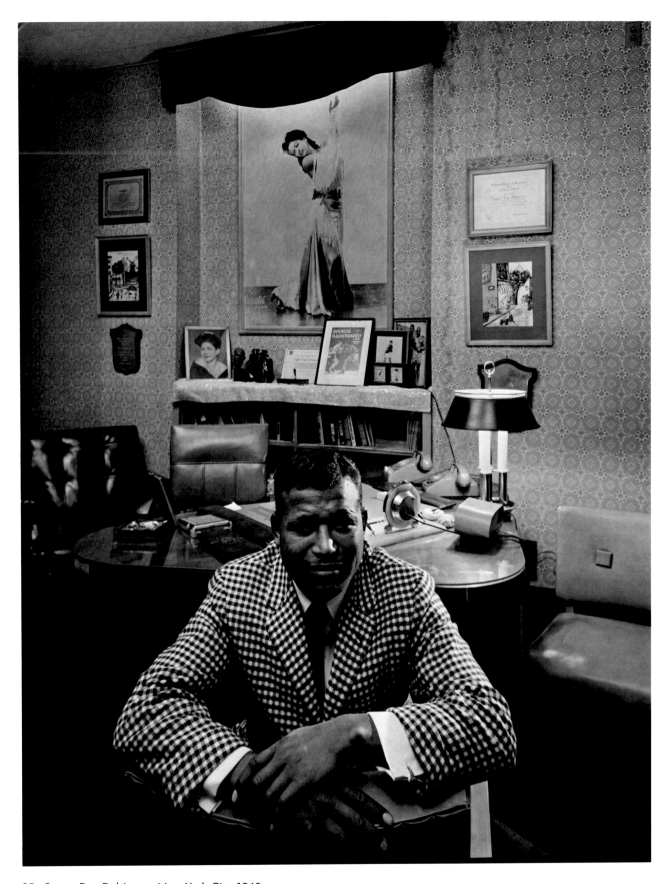

85. Sugar Ray Robinson, New York City, 1960

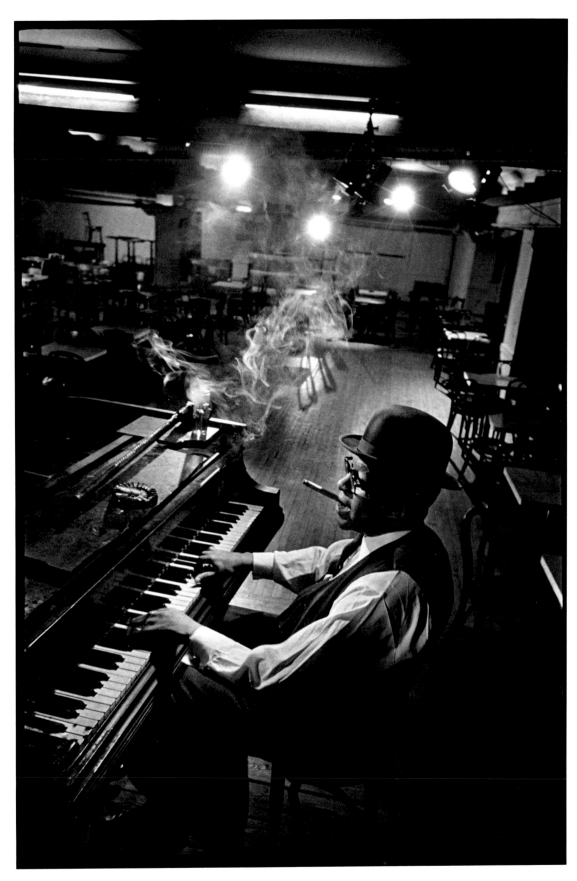

86. Willie "the Lion" Smith, New York City, 1960

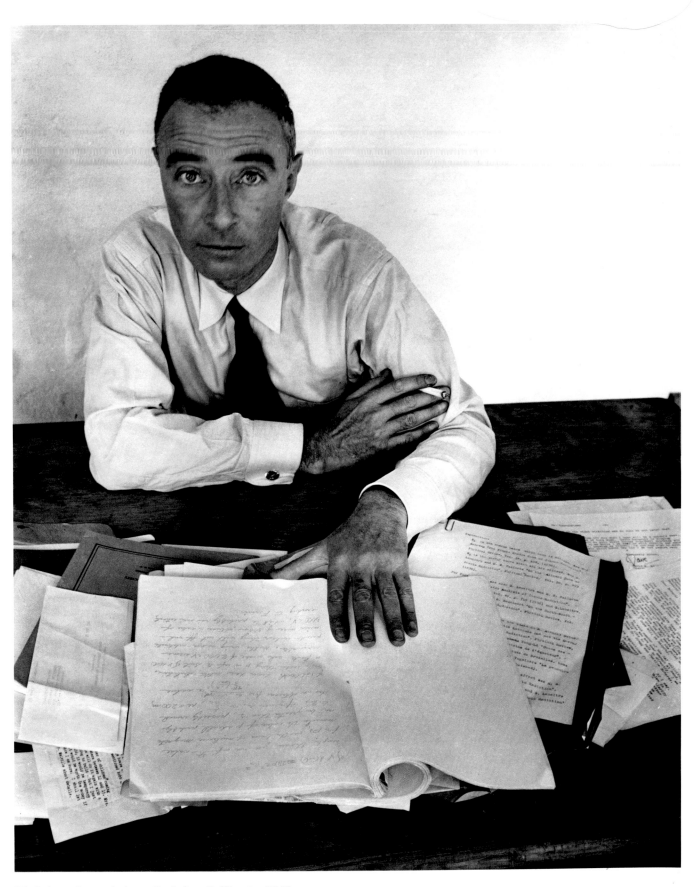

87. Robert Oppenheimer, Berkeley, California, 1948

88. Edward Teller, Waltham, Massachusetts, 1961

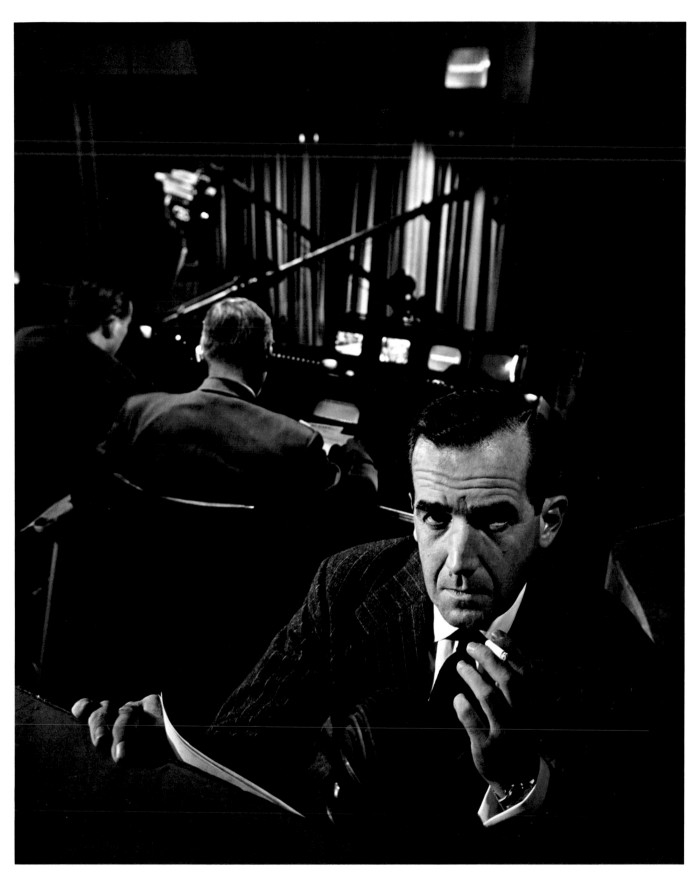

89. Edward R. Murrow, New York City, 1951

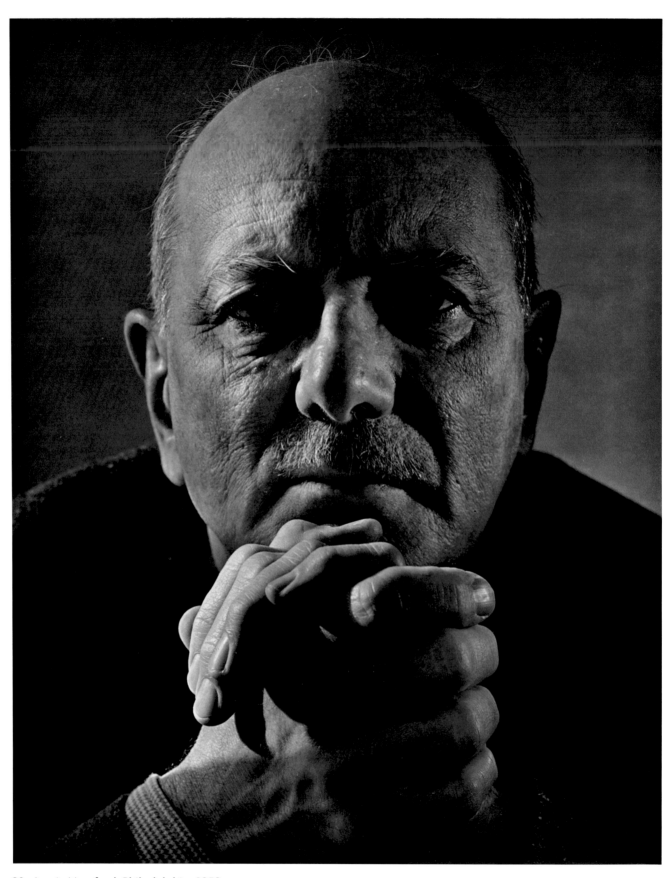

90. Lewis Mumford, Philadelphia, 1959

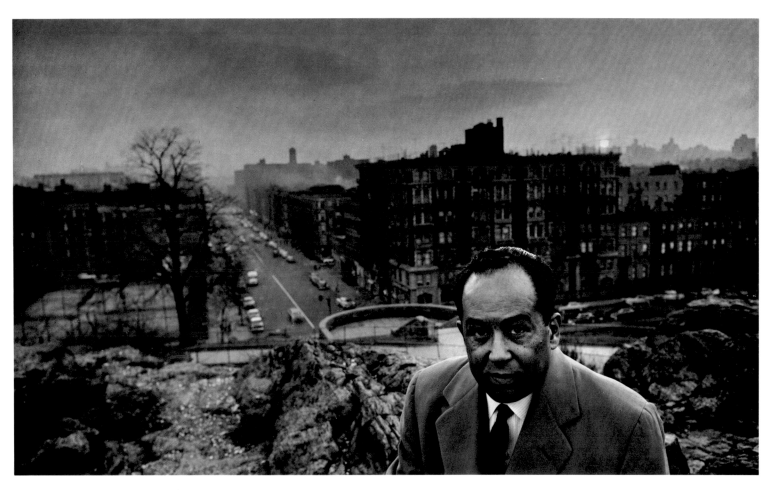

91. Langston Hughes, New York City, 1960

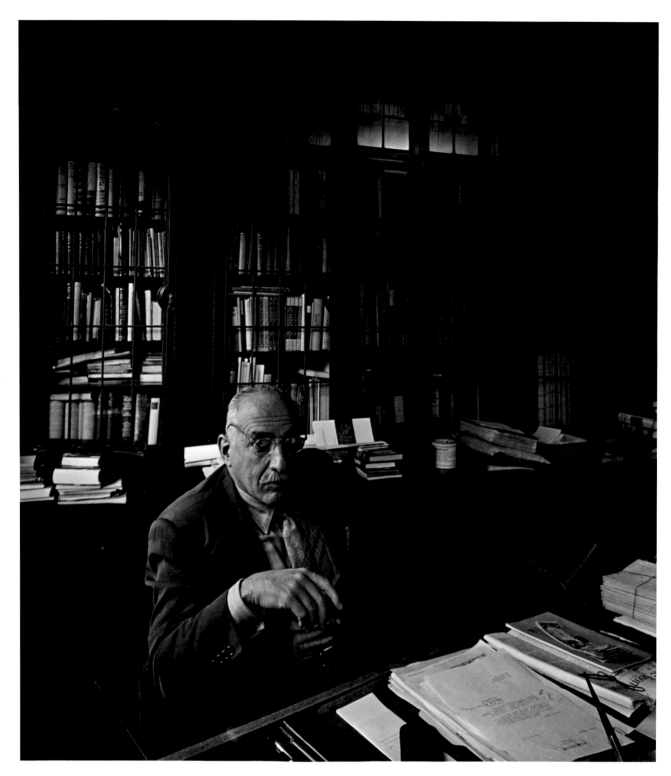

92. Alfred Knopf, New York City, 1949

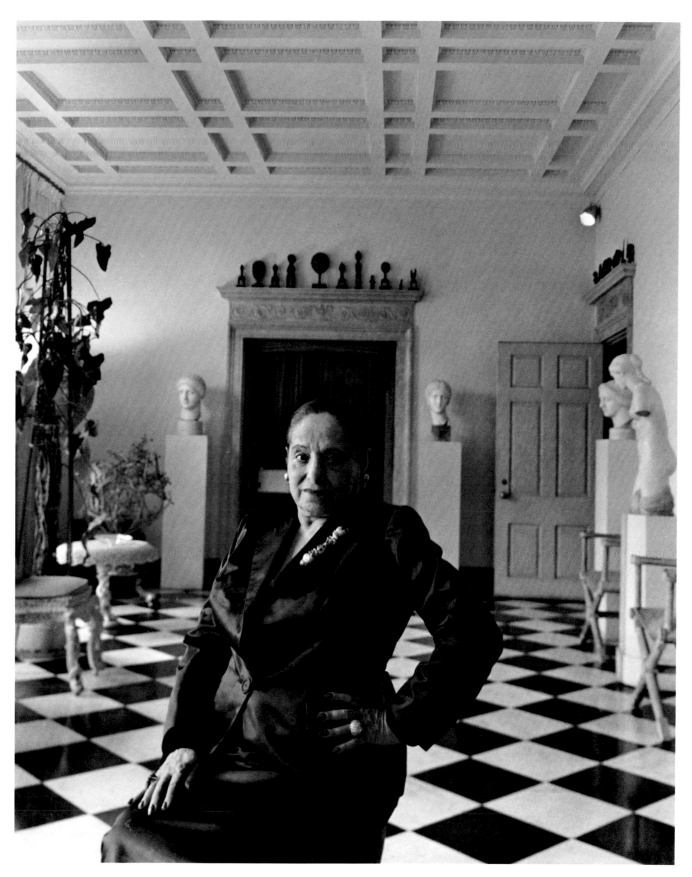

93. Helena Rubinstein, New York City, 1948

94. Alfred Kinsey, Bloomington, Indiana, 1948

95. Elie Wiesel, New York City, 1981

96. Isaac Bashevis Singer, New York City, 1968

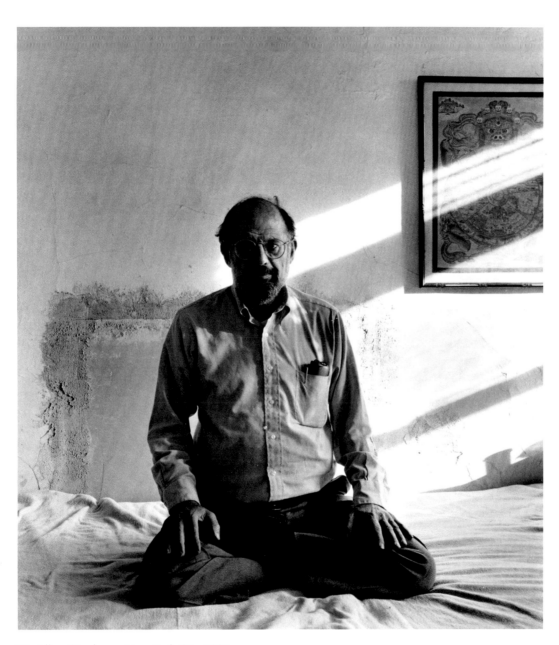

97. Allen Ginsberg, New York City, 1985

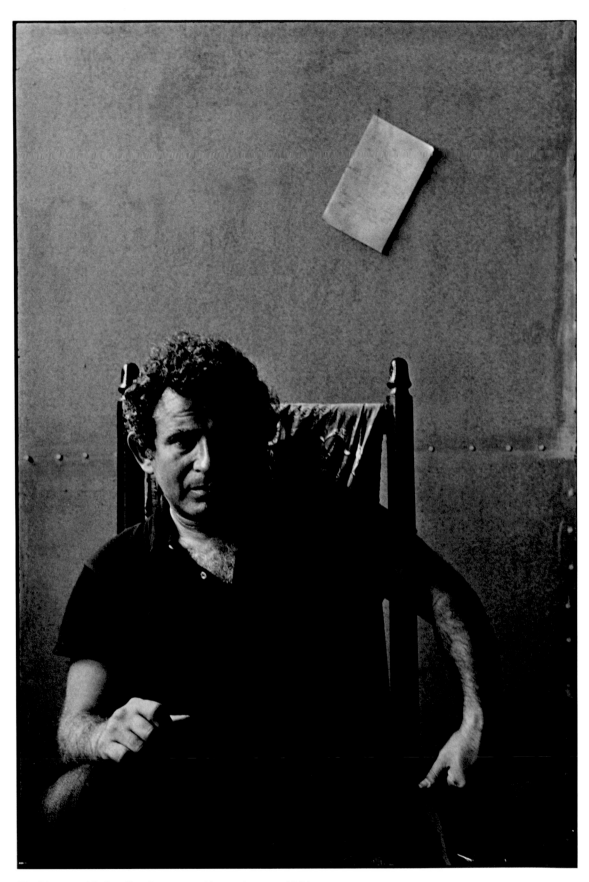

98. Norman Mailer, Provincetown, Massachusetts, 1964

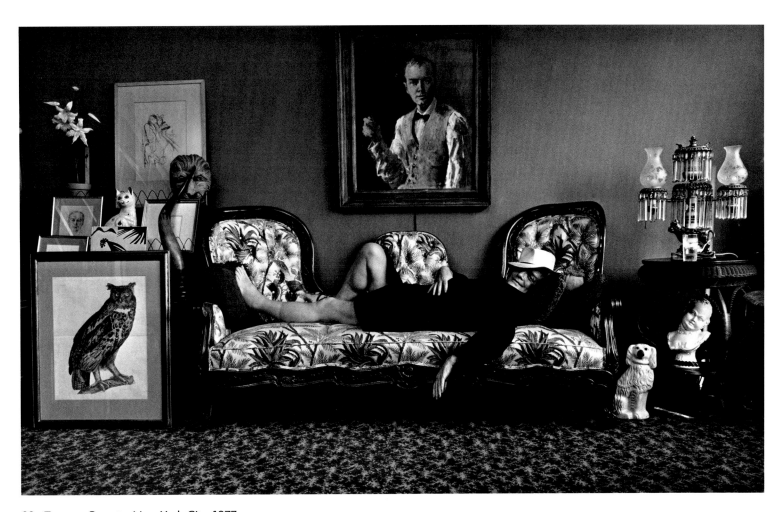

99. Truman Capote, New York City, 1977

CATALOG OF THE COLLECTION

This collection of American portraits was acquired by the National Portrait Gallery in 1991 through a joint gift and purchase from Arnold Newman. This section serves as a formal checklist of the collection, as well as a record of Newman's portrait sittings. The entries, which are arranged chronologically by sitting date, include place of sitting, negative format, image size, print format (in the case of collages and cutouts), and sitting number. The photographs, printed in gelatin silver, are the result of personal projects undertaken by Newman unless otherwise noted with a commission line. For commissioned images, the place and date of original publication are indicated, if known. The plate number of the reproduction in this book appears in brackets. It was not until the 1950s that Arnold Newman's method for recording sitting dates and negative numbers was formalized. Therefore, the information provided in this checklist for his early photographs was drawn from records that may not be accurate. Arnold Newman retains the copyright for all of his photographs, including his commissioned work.

YASUO KUNIYOSHI 1889–1953 [Pl. 7]
Artist
Place of sitting: Kuniyoshi's Fourteenth Street studio, New York City
Date of sitting: October 20, 1941
Negative format: 4 x 5 inch black and white
Image size: 36.8 x 46.3 cm (14½ x 18¼ inches)
Sitting number: 647

CHAIM GROSS 1904–1991 [Pl. 37]
Artist
Place of sitting: Gross's studio, New York City
Date of sitting: Fall 1941
Negative format: 4 x 5 inch black and white
Image size: 13.3 x 33.1 cm (5¼ x 13⅟₁₆ inches)
Sitting number: 807
Gift of Arnold Newman

JACK LEVINE born 1915 [Pl. 38]
Artist
Place of sitting: Newman's apartment, New York City
Date of sitting: January 1942
Negative format: 4 x 5 inch black and white
Image size: 32.2 x 25.9 cm (12¹¹⁄₁₆ x 10³⁄₁₆ inches)
Sitting number: 810

PIET MONDRIAN 1872–1944 [Pl. 2]
Artist
Place of sitting: Mondrian's apartment/studio, New York City
Date of sitting: Spring 1942
Negative format: 4 x 5 inch black and white
Image size: 47.4 x 27.8 cm (18¹¹⁄₁₆ x 10¹⁵⁄₁₆ inches)
Sitting number: 812
Gift of Arnold Newman

MAX ERNST 1891–1976 [Pl. 66]
Artist
Place of sitting: Peggy Guggenheim's home, New York City
Date of sitting: Spring 1942
Negative format: 4 x 5 inch black and white
Image size: 32.5 x 23.6 cm (12¹³⁄₁₆ x 9⁵⁄₁₆ inches)
Sitting number: 813

MOSES SOYER 1899–1974 and [Pl. 42]
RAPHAEL SOYER 1899–1987
Artists
Place of sitting: New York City
Date of sitting: October 1942
Negative format: 4 x 5 inch black and white
Image size: 29.8 x 20.7 cm (11¾ x 8⅛ inches)
Sitting number: 844

MARCEL DUCHAMP 1887–1968 [Pl. 39]
Artist
Place of sitting: Peggy Guggenheim's gallery, Art of This Century, New York City
Date of sitting: November 1942
Negative format: 4 x 5 inch black and white
Image size: 12.6 x 15.5 cm (4¹⁵⁄₁₆ x 6⅛ inches)
Sitting number: 850

CHARLES SHEELER 1883–1965 [Pl. 5]
Artist
Place of sitting: Museum of Modern Art, New York City
Date of sitting: November 1942
Negative format: 4 x 5 inch black and white
Image size: 21.9 x 20.8 cm (8⅝ x 8³⁄₁₆ inches)
Sitting number: 851

WILLIAM ZORACH 1887–1966 [Pl. 44]
Sculptor
Place of sitting: Zorach's studio, Brooklyn, New York
Date of sitting: September 1943
Negative format: 4 x 5 inch black and white
Image size: 31 x 25.6 cm (12³⁄₁₆ x 10¹⁄₁₆ inches)
Sitting number: 855

 [Pl. 45]
ALFRED STIEGLITZ 1861–1946, photographer, and
GEORGIA O'KEEFFE 1887–1986, artist
Place of sitting: Stieglitz's gallery, An American Place,
New York City
Date of sitting: 1944
Negative format: 4 x 5 inch black and white
Image size: 23.9 x 19.4 cm (9⁷⁄₁₆ x 7⁵⁄₈ inches)
Sitting number: 895
Gift of Arnold Newman

HORACE PIPPIN 1888–1946 [Pl. 62]
Artist
Place of sitting: West Chester, Pennsylvania
Date of sitting: Spring 1945
Negative format: 4 x 5 inch black and white
Image size: 18.3 x 23.6 cm (7³⁄₁₆ x 9⁵⁄₁₆ inches)
Sitting number: 943

GYPSY ROSE LEE 1914–1970 [Pl. 74]
Entertainer
Place of sitting: Lee's home, New York City
Date of sitting: Fall 1945
Commissioned by: Gypsy Rose Lee
Negative format: 4 x 5 inch black and white
Image size: 24.8 x 32.9 cm (9¾ x 12¹⁵⁄₁₆ inches)
Sitting number: 922

MARC BLITZSTEIN 1905–1964 [Pl. 83]
Composer, playwright
Place of sitting: Blitzstein's apartment, New York City
Date of sitting: 1945
Negative format: 4 x 5 inch black and white
Image size: 23.9 x 31.8 cm (9⁷⁄₁₆ x 12½ inches)
Sitting number: 949
Gift of Arnold Newman

EUGENE O'NEILL 1888–1953 [Pl. 71]
Playwright, Nobel laureate
Place of sitting: O'Neill's apartment, New York City
Date of sitting: September 1946
Commissioned by: Life
Published in: Variant image from same sitting in
Tom Prideaux, "Eugene O'Neill," October 14, 1946,
page 102
Negative format: 4 x 5 inch black and white
Image size: 32.7 x 24.8 cm (12⅞ x 9¾ inches)
Sitting number: 1053

IGOR STRAVINSKY 1882–1971 [Pl. 18]
Composer
Place of sitting: New York City
Date of sitting: December 1946
Commissioned by: Harper's Bazaar
Negative format: 4 x 5 inch black and white
Image size: 30.7 x 56.7 cm (12¹⁄₁₆ x 22⁵⁄₁₆ inches)
Sitting number: 1054
Gift of Arnold Newman

ARTHUR MILLER born 1915 [Pl. 77]
Playwright
Place of sitting: Rehearsal of *All My Sons*, New York City
Date of sitting: December 19, 1946
Negative format: 4 x 5 inch black and white
Image size: 32.7 x 21.6 cm (12⅞ x 8½ inches)
Sitting number: 1077

JOHN MARIN 1870–1953 [Pl. 69]
Artist
Place of sitting: Cliffside Park, New Jersey
Date of sitting: January 1947
Negative format: 4 x 5 inch black and white
Image size: 25.2 x 32.4 cm (9¹⁵⁄₁₆ x 12¾ inches)
Sitting number: 1068
Gift of Arnold Newman

ISAMU NOGUCHI 1904–1988 [Pl. 52]
Sculptor
Place of sitting: Noguchi's studio, New York City
Date of sitting: Summer 1947
Negative format: 4 x 5 inch black and white
Image size: 32.8 x 24.6 cm (12¹⁵⁄₁₆ x 9¹¹⁄₁₆ inches)
Sitting number: 1153
Gift of Arnold Newman

FRANK LLOYD WRIGHT 1867–1959 [Pl. 54]
Architect
Place of sitting: Taliesin East, Wisconsin
Date of sitting: October 1947
Negative format: 4 x 5 inch black and white
Image size: 34 x 46.7 cm (13⅜ x 18⅜ inches)
Sitting number: 1211

ALFRED KINSEY 1894–1956 [Pl. 94]
Biologist, behavioral scientist
Place of sitting: University of Indiana, Bloomington
Date of sitting: May 27, 1948
Commissioned by: Life
Published in: Variant image from same sitting
in Frances Sill Wickware, "Report on Kinsey,"
August 2, 1948, page 86
Negative format: 4 x 5 inch black and white
Image size: 30.3 x 25.3 cm (11¹⁵⁄₁₆ x 9¹⁵⁄₁₆ inches)
Sitting number: 1262
Gift of Arnold Newman

MARLENE DIETRICH born 1901 [Pl. 79]
Actress
Place of sitting: Plaza Hotel Suite, New York City
Date of sitting: July 9, 1948
Commissioned by: *Life*
Published in: Variant image from same sitting used on
the cover, August 9, 1948
Negative format: 4 x 5 inch black and white
Image size: 30.5 x 23.8 cm (12 x 9⅜ inches)
Sitting number: 1285
Gift of Arnold Newman

ROBERT OPPENHEIMER 1904–1967 [Pl. 87]
Theoretical physicist
Place of sitting: Oppenheimer's home,
Berkeley, California
Date of sitting: July 1948
Commissioned by: *Fortune*
Published in: Variant image from same sitting in
"The Scientists," October 1948, page 106
Negative format: 4 x 5 inch black and white
Image size: 32 x 25.7 cm (12⅝ x 10⅛ inches)
Sitting number: 1289

MAN RAY 1890–1976 [Pl. 40]
Photographer, artist
Place of sitting: Man Ray's apartment, Los Angeles
Date of sitting: August 1948
Negative format: 4 x 5 inch black and white
Print format: Cutout
Image size: 21.5 x 13.6 cm (8½ x 5⅜ inches)
Sitting number: 1296
Gift of Arnold Newman

HELENA RUBINSTEIN 1870–1965 [Pl. 93]
Beauty expert, entrepreneur
Place of sitting: Rubinstein's home, New York City
Date of sitting: 1948
Commissioned by: *Collier's*
Published in: Variant image from same sitting in Hambla
Bauer, "Beauty Tycoon," December 4, 1948, page 16
Negative format: 4 x 5 inch black and white
Image size: 32.4 x 25.9 cm (12¾ x 10³⁄₁₆ inches)
Sitting number: 1340
Gift of Arnold Newman

DANNY KAYE 1913–1987 [Pl. 78]
Actor, comedian
Place of sitting: Philadelphia
Date of sitting: February 1949
Commissioned by: *Seventeen* magazine
Published in: Variant image from same sitting in Edwin
Miller, "Danny Kaye," March 1950, pages 126–127
Negative format: 2¼ inch black and white
Image size: 29.7 x 25.8 cm (11¹¹⁄₁₆ x 10³⁄₁₆ inches)
Sitting number: 1349
Gift of Arnold Newman

JACKSON POLLOCK 1912–1956 [Pl. 41]
Artist
Place of sitting: Springs, Long Island, New York
Date of sitting: February 1949
Commissioned by: *Life*
Published in: Variant image from same sitting in
"Jackson Pollock," August 8, 1949, page 42
Negative format: 4 x 5 inch black and white
Image size: 46 x 36.7 cm (18⅛ x 14⁷⁄₁₆ inches)
Sitting number: 1361

GRANDMA MOSES 1860–1961 [Pl. 61]
Artist
Place of sitting: Eagle Bridge, New York
Date of sitting: October 1949
Negative format: 4 x 5 inch black and white
Image size: 45.9 x 36.9 cm (18¹⁄₁₆ x 14½ inches)
Sitting number: 1444

ALFRED KNOPF 1892–1984 [Pl. 92]
Publisher
Place of sitting: Knopf's office, New York City
Date of sitting: November 4, 1949
Commissioned by: *Fortune*
Negative format: 4 x 5 inch black and white
Image size: 29.4 x 25.7 cm (11⁹⁄₁₆ x 10⅛ inches)
Sitting number: 1448

VANNEVAR BUSH 1890–1974 [Pl. 27]
Engineer, academic administrator
Place of sitting: Bush's office, Massachusetts Institute of
Technology, Cambridge
Date of sitting: November 1949
Commissioned by: *Life*
Published in: Vannevar Bush, "Scientific Weapons and a
Future," November 14, 1949, page 112
Negative format: 4 x 5 inch black and white
Image size: 31.8 x 25.2 cm (12½ x 9¹⁵⁄₁₆ inches)
Sitting number: 1471

DWIGHT D. EISENHOWER 1890–1969 [Pl. 10]
President of Columbia University; thirty-fourth president
of the United States
Place of sitting: Columbia University, New York City
Date of sitting: March 1950
Commissioned by: *Life*
Published in: Variant image from same sitting in
Quentin Reynolds, "Mr. President Eisenhower:
A Close Up," April 7, 1950
Negative format: 4 x 5 inch black and white
Image size: 29 x 25.5 cm (11⁷⁄₁₆ x 10¹⁄₁₆ inches)
Sitting number: 1728

ALUMNI, ART STUDENTS LEAGUE [Pl. 50]
Front row, left to right: Henry Billings with his painting *On
the Defensive;* Alexander Brook (on stool); Whitney Dar-
row, Jr., *New Yorker* cartoonist; Paul Cadmus, leaning on

137

his painting *Playground;* Otto Soglow, cartoonist of *The Little King* (on stool); Robert Philipp, with portrait of a girl at his feet; Peppino Mangravite (at Philipp's knee); Peggy Bacon; Bernard Klonis (behind Bacon); Yasuo Kuniyoshi, with his still life *Four Peaches;* sculptor William Zorach (behind Kuniyoshi); Arnold Blanch (in light suit); Vaclav Vytlacil; Dean Cornwell; Will Barnet; Reginald Marsh, with elbows on one of his studies; Ben Shahn. *Back row, left to right:* Gifford Beal, three-time president of the league (with white hair), Harry Sternberg (with elbow on knee); Philip Evergood; John Groth; Ernest Fiene (behind Groth, on ladder); Russell Cowles (with bow tie); Henry Schnakenberg (behind Cowles, against wall); Adolph Dehn; Kenneth Hayes Miller, a league teacher; Stewart Klonis, executive director of the league (on high stool); Christian Buchheit, league superintendent (against wall); Frank V. DuMond, a league teacher; Eugene Speicher; Ogden Pleissner, *Life* artist correspondent of World War II; sculptor Chaim Gross; Sidney Dickinson; Louis Bouché
Place of sitting: New York City
Date of sitting: June 2, 1950
Commissioned by: Life
Published in: Variant image from same sitting in "Artist Alumni," October 16, 1950, pages 172–173
Negative format: 8 x 10 inch black and white
Image size: 27.3 x 48.1 cm (10¾ x 18¹⁵⁄₁₆ inches)
Sitting number: 1745
Gift of Arnold Newman

BROOKS ATKINSON 1894–1984 [Pl. 73]
Theater critic, journalist
Place of sitting: Morosco Theater, New York City
Date of sitting: May 10, 1951
Commissioned by: New York Times (promotion)
Negative format: 4 x 5 inch black and white
Image size: 34 x 27 cm (13⅜ x 10⅝ inches)
Sitting number: 1882

EDWARD R. MURROW 1908–1965 [Pl. 89]
News and public affairs broadcaster
Place of sitting: CBS studio, New York City
Date of sitting: October 17, 1951
Commissioned by: CBS
Negative format: 4 x 5 inch black and white
Image size: 31.6 x 25.6 cm (12⁷⁄₁₆ x 10¹⁄₁₆ inches)
Sitting number: 1913

WALTER F. GEORGE 1878–1957 [Pl. 35]
United States senator
Place of sitting: Vienna, Georgia
Date of sitting: December 1951
Commissioned by: Fortune
Published in: Variant image from same sitting in "The Southern Delegation," February 1952, page 87
Negative format: 4 x 5 inch black and white
Image size: 33.9 x 27 cm (13⅜ x 10⅝ inches)
Sitting number: 1939
Gift of Arnold Newman

HANS HOFMANN 1880–1966 [Pl. 63]
Artist
Place of sitting: Hofmann's studio, Provincetown, Massachusetts
Date of sitting: September 1952
Negative format: 4 x 5 inch black and white
Image size: 32.3 x 25.4 cm (12¾ x 10 inches)
Sitting number: 2034
Gift of Arnold Newman

JOHN F. KENNEDY 1917–1963 [Pl. 11]
United States senator; thirty-fifth president of the United States
Place of sitting: Senate Office Building, Washington, D.C.
Date of sitting: June 25, 1953
Commissioned by: Holiday
Negative format: 4 x 5 inch black and white
Image size: 32.2 x 25.8 cm (12¹¹⁄₁₆ x 10³⁄₁₆ inches)
Sitting number: 2111

WAYNE MORSE 1900–1974 [Pl. 13]
United States senator
Place of sitting: Senate Office Building, Washington, D.C.
Date of sitting: July 9, 1953
Commissioned by: Holiday
Published in: Blair Moody, "The United States Senate," February 1954, page 59
Negative format: 2¼ inch black and white
Image size: 32.9 x 20.7 cm (12¹⁵⁄₁₆ x 8⅛ inches)
Sitting number: 2115

LYNDON BAINES JOHNSON 1908–1973 [Pl. 17]
Senate majority leader; thirty-sixth president of the United States
Place of sitting: Senate Office Building, Washington, D.C.
Date of sitting: July 12, 1953
Commissioned by: Holiday
Published in: Blair Moody, "The United States Senate," February 1954, page 57
Negative format: 4 x 5 inch black and white
Image size: 34.2 x 26.6 cm (13⁷⁄₁₆ x 10½ inches)
Sitting number: 2120

JOSEPH McCARTHY 1908–1957 [Pl. 15]
United States senator
Place of sitting: Senate Office Building, Washington, D.C.
Date of sitting: July 14, 1953
Commissioned by: Holiday
Published in: Variant image from same sitting in Blair Moody, "The United States Senate," February 1954, page 62
Negative format: 2¼ inch black and white
Image size: 25.1 x 30.9 cm (9⅞ x 12³⁄₁₆ inches)
Sitting number: 2123

RICHARD M. NIXON born 1913 [Pl. 14]
Vice president of the United States; thirty-seventh
president of the United States
Place of sitting: Senate Office Building,
Washington, D.C.
Date of sitting: September 28, 1953
Commissioned by: Richard M. Nixon
Negative format· 4 x 5 inch black and white
Image size: 31.2 x 25.5 cm (12⁵⁄₁₆ x 10¹⁄₁₆ inches)
Sitting number· 2147

CARL SANDBURG 1878–1967 [Pl. 81]
Poet
Place of sitting: Newman's studio, New York City
Date of sitting: November 3, 1955
Commissioned by: Life (promotion)
Negative format: 4 x 5 inch black and white
Image size: 47.4 x 37.5 cm (18¹¹⁄₁₆ x 14¾ inches)
Sitting number: 2401

ROBERT FROST 1874–1963 [Pl. 24]
Poet
Place of sitting: Algonquin Hotel, New York City
Date of sitting: March 23, 1956
Commissioned by: Life (promotion)
Negative format: 2¼ inch black and white
Image size: 38 x 37.3 cm (14¹⁵⁄₁₆ x 14¹¹⁄₁₆ inches)
Sitting number: 2472

KURT GÖDEL 1906–1978 [Pl. 30]
Logician, educator
Place of sitting: Gödel's office, Institute for Advanced
Study, Princeton, New Jersey
Date of sitting: May 1, 1956
Commissioned by: Scientific American
Published in: Variant image from same sitting in
Ernest Nagel and James R. Newman, "Gödel's Proof,"
June 1956, page 72
Negative format: 4 x 5 inch black and white
Image size: 30.4 x 24.8 cm (12 x 9¾ inches)
Sitting number: 2488
Gift of Arnold Newman

JOSEPH WELCH 1890–1960 [Pl. 36]
Lawyer
Place of sitting: Welch's office, Boston
Date of sitting: February 21, 1957
Commissioned by: Life (promotion)
Negative format: 4 x 5 inch black and white
Image size: 32.5 x 25.9 cm (12¹³⁄₁₆ x 10³⁄₁₆ inches)
Sitting number: 2613
Gift of Arnold Newman

DAVID SMITH 1906–1965 [Pl. 43]
Sculptor
Place of sitting: Museum of Modern Art, New York City
Date of sitting: October 20, 1957

Negative format: 4 x 5 inch black and white
Image size: 32.7 x 24.1 cm (12⅞ x 9½ inches)
Sitting number: 2722

LEWIS MUMFORD 1895–1990 [Pl. 90]
Social philosopher, cultural historian
Place of sitting: Mumford's home, Philadelphia
Date of sitting· February 3, 1959
Commissioned by: Saturday Evening Post
Published in· Variant image from same sitting in
Lewis Mumford, "Adventures of the Mind: How the
War Began," April 18, 1959, page 25
Negative format: 4 x 5 inch black and white
Image size: 32.6 x 25.5 cm (12¹³⁄₁₆ x 10¹⁄₁₆ inches)
Sitting number: 2960
Gift of Arnold Newman

JACOB LAWRENCE born 1917 [Pl. 4]
Artist, educator
Place of sitting: Lawrence's apartment/studio,
Brooklyn, New York
Date of sitting: March 29, 1959
Negative format: 4 x 5 inch black and white
Image size: 32.2 x 25.6 cm (12¹¹⁄₁₆ x 10¹⁄₁₆ inches)
Sitting number: 2975
Gift of Arnold Newman

AARON COPLAND 1900–1990 [Pl. 20]
Composer
Place of sitting: Copland's home, Ossining, New York
Date of sitting: May 18, 1959
Commissioned by: Saturday Evening Post
Published in: Aaron Copland, "The Pleasures of Music,"
July 4, 1959, page 18
Negative format: 4 x 5 inch black and white
Image size: 31.7 x 48.5 cm (12½ x 19¹⁄₁₆ inches)
Sitting number: 2991

WILLEM DE KOONING born 1904 [Pl. 8]
Artist
Place of sitting: de Kooning's studio, New York City
Date of sitting: May 25, 1959
Negative format: 4 x 5 inch black and white
Image size: 25.3 x 25.4 cm (9¹⁵⁄₁₆ x 10 inches)
Sitting number: 2992

ROBERT MOSES 1888–1981 [Pl. 33]
New York public official
Place of sitting: Welfare Island, New York City
Date of sitting: June 4, 1959
Commissioned by: Holiday
Published in: Aubrey Menen, "A First Look at New York,"
October 1959, pages 50–51
Negative format: 4 x 5 inch black and white
Image size: 24 x 33 cm (9⁷⁄₁₆ x 13 inches)
Sitting number: 2999

LANGSTON HUGHES 1902–1967 [Pl. 91]
Poet
Place of sitting: Mt. Morris Park, Harlem,
New York City
Date of sitting: January 29, 1960
Commissioned by: Holiday
Published in: Variant image from same sitting in
Peter Abrahams, "The Meaning of Harlem," June 1960,
page 75
Negative format: 4 x 5 inch black and white
Image size: 20.7 x 34.5 cm (8⅛ x 13⁹⁄₁₆ inches)
Sitting number: 4008

WILLIE "THE LION" SMITH 1897–1973 [Pl. 86]
Jazz pianist, composer
Place of sitting: "Small's Paradise," Harlem,
New York City
Date of sitting: March 1960
Commissioned by: Holiday
Published in: Variant image from same sitting in
Peter Abrahams, "The Meaning of Harlem," June 1960,
page 81
Negative format: 35 mm black and white
Image size: 32.8 x 21.8 cm (12¹⁵⁄₁₆ x 8⁹⁄₁₆ inches)
Sitting number: 4033
Gift of Arnold Newman

SUGAR RAY ROBINSON 1921–1989 [Pl. 85]
Boxer, world middleweight champion
Place of sitting: Robinson Enterprises, Harlem,
New York City
Date of sitting: March 1960
Commissioned by: Holiday
Published in: Peter Abrahams, "The Meaning of
Harlem," June 1960, page 77
Negative format: 4 x 5 inch black and white
Image size: 32.9 x 25.2 cm (12¹⁵⁄₁₆ x 9¹⁵⁄₁₆ inches)
Sitting number: 4034

HARRY S TRUMAN 1884–1972 [Pl. 16]
Thirty-third president of the United States
Place of sitting: Carlyle Hotel, New York City
Date of sitting: June 19, 1960
Commissioned by: Life
Published in: Variant image from same sitting in
"Presidency," July 4, 1960, page 23
Negative format: 4 x 5 inch color
Image size: 42 x 34.6 cm (16⁹⁄₁₆ x 13⅝ inches)
Sitting number: 4072

EDWARD HOPPER 1882–1967 and his wife, Jo [Pl. 60]
Artist
Place of sitting: Truro, Massachusetts
Date of sitting: August 1960
Commissioned by: Horizon
Published in: Variant image from same sitting in Robert
Hatch, "At the Tip of Cape Cod," July 1961, page 10

Negative format: 4 x 5 inch black and white
Image size: 56.7 x 45.2 cm (22⁵⁄₁₆ x 17¹³⁄₁₆ inches)
Sitting number: 4098

MILTON AVERY 1885–1965 [Pl. 47]
Artist
Place of sitting: Avery's studio, New York City
Date of sitting: January 6, 1961
Commissioned by: Horizon
Published in: Robert Hatch, "At the Tip of Cape Cod,"
July 1961, page 28
Negative format: 4 x 5 inch black and white
Image size: 38 x 47.3 cm (14¹⁵⁄₁₆ x 18⅝ inches)
Sitting number: 4150
Gift of Arnold Newman

MARTHA GRAHAM 1894–1991 [Pl. 19]
Dancer, choreographer
Place of sitting: Graham's school, New York City
Date of sitting: March 1961
Negative format: 4 x 5 inch black and white
Image size: 30.9 x 48.9 cm (12³⁄₁₆ x 19¼ inches)
Sitting number: 4168

JAMES JONES 1921–1977 [Pl. 70]
Author
Place of sitting: Jones's apartment, Paris, France
Date of sitting: April 19, 1961
Negative format: 2¼ inch black and white
Image size: 26.5 x 25.7 cm (10⁷⁄₁₆ x 10⅛ inches)
Sitting number: 4196
Gift of Arnold Newman

MIKE MANSFIELD born 1903 [Pl. 12]
Senate majority leader
Place of sitting: Washington, D.C.
Date of sitting: November 14, 1961
Commissioned by: Holiday
Published in: Variant image from same sitting in
"Washington: The City of Our Time," April 1962,
pages 54–55
Negative format: 4 x 5 inch black and white and color
Image size: 32.1 x 25.2 cm (12⅝ x 9¹⁵⁄₁₆ inches)
Sitting number: 4276

EDWARD TELLER born 1908 [Pl. 88]
Physicist
Place of sitting: Waltham, Massachusetts
Date of sitting: December 21, 1961
Commissioned by: Saturday Evening Post
Published in: Variant image from same sitting in
Edward Teller with Allen Brown, "Plan for Survival,"
February 3, 1962, page 11
Negative format: 4 x 5 inch black and white
Image size: 27.7 x 25.4 cm (10¹⁵⁄₁₆ x 10 inches)
Sitting number: 4290
Gift of Arnold Newman

MARILYN MONROE 1926–1962 [Pl. 80]
Actress
Place of sitting: Henry Weinstein's home, Beverly Hills,
California
Date of sitting: January 1962
Published in: Variant image from same sitting
in Carl Sandburg, "A Tribute to Marilyn," *Look,*
September 11, 1962, page 90
Negative format: 35 mm black and white
Image size: 23.2 x 32.2 cm (9⅛ x 12¹¹/₁₆ inches)
Sitting number: 4296

ELEANOR ROOSEVELT 1884–1962 [Pl. 31]
First Lady, humanitarian
Place of sitting: New York City
Date of sitting: January 25, 1962
Negative format: 4 x 5 inch black and white
Image size: 44.9 x 37.1 cm (17¹¹/₁₆ x 14⅝ inches)
Sitting number: 4301

THORNTON WILDER 1897–1975 [Pl. 72]
Author
Place of sitting: Newman's studio, New York City
Date of sitting: January 28, 1962
Negative format: 4 x 5 inch black and white
Image size: 31.5 x 25.2 cm (12⅜ x 9¹⁵/₁₆ inches)
Sitting number: 4302

HENRY LUCE 1898–1967 [Pl. 34]
Editor, publisher
Place of sitting: Luce's office, New York City
Date of sitting: January 30, 1962
Negative format: 4 x 5 inch black and white
Image size: 32.8 x 25.7 cm (12¹⁵/₁₆ x 10⅛ inches)
Sitting number: 4304

ADLAI STEVENSON 1900–1965 [Pl. 32]
Statesman
Place of sitting: United Nations, New York City
Date of sitting: March 12, 1962
Negative format: 4 x 5 inch black and white
Image size: 34.6 x 27 cm (13⅝ x 10⅝ inches)
Sitting number: 4320

FREDERICK KIESLER 1892–1965 [Pl. 67]
Architect, sculptor
Place of sitting: Kiesler's studio, New York City
Date of sitting: March 17, 1962
Negative format: 4 x 5 inch black and white
Image size: 43.2 x 34.1 cm (17 x 13⁷/₁₆ inches)
Sitting number: 4323
Gift of Arnold Newman

ZERO MOSTEL 1915–1977 [Pl. 9]
Actor
Place of sitting: Mostel's studio, New York City
Date of sitting: December 14, 1962
Commissioned by: Holiday

Published in: Variant image from same sitting in Hugh G.
Foster, "The Infinite Zero," March 1963, page 131
Negative format: 4 x 5 inch black and white
Image size: 31.8 x 25.5 cm (12½ x 10¹/₁₆ inches)
Sitting number: 4430
Gift of Arnold Newman

JIMMY VAN HEUSEN 1913–1990, composer, [Pl. 75]
and SAMMY CAHN born 1913, lyricist
Place of sitting: Van Heusen's home, Palm Springs,
California
Date of sitting: January 13, 1963
Commissioned by: Show magazine
Published in: C. Robert Jennings, "Cahn and
Van Heusen: Hollywood's Tin Pan Aladdins," July 1963,
page 77
Negative format: 4 x 5 inch black and white
Image size: 34.1 x 27.1 cm (13⁷/₁₆ x 10¹¹/₁₆ inches)
Sitting number: 4436
Gift of Arnold Newman

NORMAN MAILER born 1923 [Pl. 98]
Author
Place of sitting: Mailer's studio, Provincetown,
Massachusetts
Date of sitting: August 1964
Negative format: 35 mm black and white
Image size: 24.4 x 16.6 cm (9⅝ x 6⁹/₁₆ inches)
Sitting number: 4591
Gift of Arnold Newman

JAMES WATSON born 1928 [Pl. 29]
Molecular biologist, Nobel laureate
Place of sitting: Harvard University, Cambridge,
Massachusetts
Date of sitting: September 12, 1964
Commissioned by: Time-Life Books
Negative format: 4 x 5 inch black and white
Image size: 25.1 x 27.9 cm (9⅞ x 11 inches)
Sitting number: 4595

AYN RAND 1905–1982 [Pl. 23]
Author, lecturer
Place of sitting: New York City
Date of sitting: September 14, 1964
Commissioned by: New American Library
Negative format: 4 x 5 inch black and white
Image size: 30.8 x 24.7 cm (12⅛ x 9¾ inches)
Sitting number: 4596

PAUL STRAND 1890–1976 [Pl. 6]
Photographer
Place of sitting: Newman's studio, New York City
Date of sitting: January 30, 1966
Negative format: 4 x 5 inch black and white
Image size: 31.4 x 25.9 cm (12⅜ x 10³/₁₆ inches)
Sitting number: 4797
Gift of Arnold Newman

I. M. PEI born 1917 [Pl. 53]
Architect
Place of sitting: Pei's office, New York City
Date of sitting: September 23, 1967
Commissioned by: I. M. Pei
Negative format: 4 x 5 inch black and white
Image size: 48.1 x 38.1 cm (11¹⁵⁄₁₆ x 15 inches)
Sitting number: 5105
Gift of Arnold Newman

CLAES OLDENBURG born 1929 [Pl. 65]
Artist
Place of sitting: Oldenburg's studio, New York City
Date of sitting: October 15, 1967
Commissioned by: Look
Published in: Variant image from same sitting in
Philip Leider, ''Gallery '68: High Art and Low Art,''
January 9, 1968, pages 18–19
Negative format: 4 x 5 inch black and white
Image size: 25.2 x 32.6 cm (9¹⁵⁄₁₆ x 12¹³⁄₁₆ inches)
Sitting number: 5111
Gift of Arnold Newman

ISAAC BASHEVIS SINGER 1904–1991 [Pl. 96]
Author, Nobel laureate
Place of sitting: Singer's apartment, New York City
Date of sitting: February 29, 1968
Negative format: 4 x 5 inch black and white
Image size: 33.2 x 25.1 cm (13¹⁄₁₆ x 9⅞ inches)
Sitting number: 5174

LEONARD BERNSTEIN 1918–1990 [Pl. 21]
Conductor, composer
Place of sitting: New York Philharmonic Hall,
New York City
Date of sitting: May 2, 1968
Commissioned by: Holiday
Published in: Variant image from same sitting in
Clive Barnes, ''Lincoln Center,'' September 1968,
pages 40–41
Negative format: 35 mm color
Image size: 25.1 x 32.8 cm (9⅞ x 12¹⁵⁄₁₆ inches)
Sitting number: 5210

GEORGIA O'KEEFFE 1887–1986 [Pl. 68]
Artist
Place of sitting: Ghost Ranch, New Mexico
Date of sitting: August 2, 1968
Commissioned by: Holiday
Published in: Variant image from same sitting in
Charles Brossard, ''Santa Fe – Our Last Unspoiled City?''
May 1969, pages 64–65
Negative format: 35 mm black and white
Image size: 57.6 x 38.6 cm (22¹¹⁄₁₆ x 15³⁄₁₆ inches)
Sitting number: 5233
Gift of Arnold Newman

BARNETT NEWMAN 1905–1970 [Pl. 51]
Artist
Place of sitting: Metropolitan Museum of Art,
New York City
Date of sitting: February 6, 1970
Negative format: 4 x 5 inch black and white
Print format: Printed collage
Image size: 26.5 x 18.4 cm (10⁷⁄₁₆ x 7¼ inches)
Sitting number: 5452
Gift of Arnold Newman

LOUISE NEVELSON 1899–1988 [Pl. 56]
Sculptor
Place of sitting: Nevelson's studio, New York City
Date of sitting: August 29, 1972
Negative format: 4 x 5 inch black and white
Print format: Collage
Image size: 30.8 x 25 cm (12⅛ x 9⅞ inches)
Sitting number: 5718
Gift of Arnold Newman

ANDY WARHOL 1928–1987 Version 2 [Pl. 48]
Artist
Place of sitting: Warhol's Factory, New York City
Date of sitting: February 2, 1973
Commissioned by: Town & Country
Negative format: 2¼ inch black and white
Print format: Collage
Image size: 50.1 x 43.5 cm (19¾ x 17⅛ inches)
Mount size: 76.4 x 60.9 cm (30¹⁄₁₆ x 23¹⁵⁄₁₆ inches)
Sitting number: 5794
Gift of Arnold Newman

DIANA VREELAND 1903–1989 [Pl. 49]
Fashion editor, museum consultant
Place of sitting: Vreeland's apartment, New York City
Date of sitting: August 25, 1974
Commissioned by: Town & Country
Published in: Ted Burke, ''Mrs. Vreeland,'' June 1975,
page 78
Negative format: 4 x 5 inch black and white
Image size: 33.1 x 25.1 cm (13¹⁄₁₆ x 9⅞ inches)
Sitting number: 5992

JONAS SALK born 1914 [Pl. 28]
Physician, scientist
Place of sitting: Salk Institute, La Jolla, California
Date of sitting: February 25, 1975
Negative format: 35 mm black and white
Image size: 23.1 x 34.6 cm (9¹⁄₁₆ x 13⅝ inches)
Sitting number: 6065
Gift of Arnold Newman

LARRY RIVERS born 1923 [Pl. 55]
Artist
Place of sitting: Southampton, New York
Date of sitting: August 3, 1975

Negative format: 35 mm black and white
Print format: Collage
Image size: 16.3 x 24.2 cm (6⁷⁄₁₆ x 9⁹⁄₁₆ inches)
Sitting number: 6113
Gift of Arnold Newman

HENRY MILLER 1891–1980 [Pl. 64]
Author
Place of sitting: Miller's home, Los Angeles
Date of sitting: April 17, 1976
Negative format: 35 mm black and white
Print format: Collage
Image size: 35.1 x 27.8 cm (13¹³⁄₁₆ x 10¹⁵⁄₁₆ inches)
Sitting number: 6206
Gift of Arnold Newman

ANDREW WYETH born 1917 [Pl. 59]
Artist
Place of sitting: Chadds Ford, Pennsylvania
Date of sitting: December 2, 1976
Commissioned by: People magazine
Published in: "Andrew Wyeth: America's Most Popular
Painter? The Thought Grieves Some Critics,"
December 27–January 3, 1977, pages 26–27
Negative format: 2¼ inch black and white
Image size: 27.4 x 26.7 cm (10¹³⁄₁₆ x 10½ inches)
Sitting number: 6282

W. EUGENE SMITH 1918–1978 [Pl. 82]
Photographer
Place of sitting: Smith's studio, New York City
Date of sitting: March 1, 1977
Commissioned by: DU magazine
Published in: Variant image from same sitting in
"14 Photographers of New York," September 1977,
page 52
Negative format: 4 x 5 inch black and white
Image size: 28.2 x 25.2 cm (11⅛ x 9¹⁵⁄₁₆ inches)
Sitting number: 6312
Gift of Arnold Newman

RON CARTER born 1937 [Pl. 76]
Jazz musician
Place of sitting: Newman's studio, New York City
Date of sitting: May 17, 1977
Commissioned by: Fantasy Records
Published in: Variant image from same sitting used
on album cover, The Ron Carter Quartet, Piccolo,
Milestone Records, 1977
Negative format: 35 mm black and white
Image size: 34.3 x 23.5 cm (13½ x 9¼ inches)
Sitting number: 6339
Gift of Arnold Newman

TRUMAN CAPOTE 1924–1984 [Pl. 99]
Author
Place of sitting: Capote's apartment, New York City
Date of sitting: June 28, 1977
Commissioned by: Travel & Leisure

Negative format: 2¼ inch black and white
Image size: 20.7 x 33.5 cm (8⅛ x 13³⁄₁₆ inches)
Sitting number: 6348

ELIE WIESEL born 1928 [Pl. 95]
Author, Nobel laureate
Place of sitting: Wiesel's office, New York City
Date of sitting: 1981
Commissioned by: Summit Books
Published in: Elie Wiesel, The Testament, dust jacket,
1981
Negative format: 4 x 5 inch black and white
Image size: 32 x 25 cm (12⅝ x 9¹³⁄₁₆ inches)
Sitting number: 6693
Gift of Arnold Newman

PHILIP GLASS born 1937 [Pl. 84]
Composer, musician
Place of sitting: New York City
Date of sitting: May 14, 1981
Commissioned by: Life
Published in: Todd Brewster, "Portrait: Philip Glass:
Composing Classics from Raga to Rock," August 1981,
page 19
Negative format: 4 x 5 inch black and white
Image size: 25.6 x 25.2 cm (10¹⁄₁₆ x 9¹⁵⁄₁₆ inches)
Sitting number: 6736
Gift of Arnold Newman

ARNO PENZIAS born 1933 [Pl. 25]
Astrophysicist, Nobel laureate
Place of sitting: Bell Laboratories, Murray Hill,
New Jersey
Date of sitting: February 20, 1985
Commissioned by: AT&T
Negative format: 4 x 5 inch black and white
Image size: 24.3 x 33.5 cm (9⁹⁄₁₆ x 13³⁄₁₆ inches)
Sitting number: 7127

MARISOL born 1930 [Pl. 58]
Sculptor
Place of sitting: George Segal's studio, New Jersey
Date of sitting: July 20, 1985
Negative format: 35 mm black and white
Image size: 33.3 x 22 cm (13⅛ x 8¹¹⁄₁₆ inches)
Sitting number: 7167
Gift of Arnold Newman

GEORGE SEGAL born 1924 [Pl. 57]
Sculptor
Place of sitting: Segal's studio, New Jersey
Date of sitting: August 6, 1985
Commissioned by: Frankfurter Allgemeine Magazin
Published in: Von Jordan Mejias, "George Segal,"
August 21, 1987, page 13
Negative format: 4 x 5 inch black and white
Image size: 32.6 x 25.8 cm (12¹³⁄₁₆ x 10³⁄₁₆ inches)
Sitting number: 7169
Gift of Arnold Newman

ISAAC STERN born 1920 [Pl. 22]
Violinist
Place of sitting: Stern's studio, New York City
Date of sitting: September 23, 1985
Commissioned by: Musical America
Published in: Variant image from same sitting in
International Directory of the Performing Arts, 1986
Negative format: 4 x 5 inch black and white
Image size: 24.3 x 22.2 cm (9⁹⁄₁₆ x 8¾ inches)
Sitting number: 7190

ALLEN GINSBERG born 1926 [Pl. 97]
Poet
Place of sitting: Ginsberg's studio, New York City
Date of sitting: November 1, 1985
Negative format: 2¼ inch black and white
Image size: 29 x 25.6 cm (11⁷⁄₁₆ x 10¹⁄₁₆ inches)
Sitting number: 7201
Gift of Arnold Newman

THEODOR GEISEL (Dr. Seuss) 1904–1991 [Pl. 1]
Author, artist
Place of sitting: La Jolla, California
Date of sitting: November 15, 1985
Negative format: 2¼ inch black and white
Print format: Collage
Image size: 36.5 x 27.7 cm (14⅜ x 10⅞ inches)
Mount size: 61 x 50.8 cm (24 x 20 inches)
Sitting number: 7214
Gift of Arnold Newman

BERENICE ABBOTT 1898–1991 [Pl. 46]
Photographer
Place of sitting: Newman's studio, New York City
Date of sitting: January 13, 1986
Commissioned by: American Photographer
Published in: Erla Zwingle, "Life of Her Own,"
March 1986, page 55
Negative format: 4 x 5 inch black and white
Image size: 32.1 x 25.2 cm (12⅝ x 9¹⁵⁄₁₆ inches)
Sitting number: 7219
Gift of Arnold Newman

TWYLA THARP born 1941 [Pl. 3]
Choreographer
Place of sitting: Tharp's apartment, New York City
Date of sitting: May 14, 1987
Commissioned by: Town & Country
Published in: Variant image from same sitting in
Wendy Lyon Moonan, "On Central Park West,"
September 1987, page 257
Negative format: 2¼ inch black and white
Image size: 24.4 x 25.5 cm (9⅝ x 10¹⁄₁₆ inches)
Sitting number: 7344
Gift of Arnold Newman

ARNOLD NEWMAN born 1918 [page 6]
Photographer
Place of sitting: Newman's studio, New York City
Date of sitting: October 19, 1987
Commissioned by: Art News
Published in: Susan Weiley, "Newman's People,"
December 1987, page 128
Negative format: 2¼ inch black and white
Image size: 17.7 x 18.7 cm (7 x 7⅜ inches)
Sitting number: 7372
Gift of Arnold Newman

 [Pl. 26]
FELLOWS OF THE INSTITUTE FOR ADVANCED
STUDY, PRINCETON, NEW JERSEY
Director Marvin L. Goldberger, seated left;
Pierre Deligne, professor in the School of Mathematics;
Clifford Geertz, professor in the School of Social
Science; Edward Witten, professor in the School of
Natural Sciences; George F. Kennan, professor emeritus
in the School of Historical Studies
Place of sitting: Institute for Advanced Study, Princeton,
New Jersey
Date of sitting: May 10, 1988
Commissioned by: Town & Country
Published in: Patricia Linden, "The Thinkers,"
October 1989, page 235
Negative format: 4 x 5 inch black and white
Image size: 25.5 x 25.2 cm (10¹⁄₁₆ x 9¹⁵⁄₁₆ inches)
Sitting number: 7410
Gift of Arnold Newman

ISAAC ASIMOV born 1920 [Frontis.]
Biochemist, author
Place of sitting: Newman's studio, New York City
Date of sitting: December 21, 1990
Commissioned by: Interview magazine
Published in: Philip Glass, "Books: Isaac Asimov
via Philip Glass," May 1991, page 68
Negative format: 2¼ inch black and white
Image size: 26.3 x 25.9 cm (10⅜ x 10³⁄₁₆ inches)
Sitting number: 7581
Gift of Arnold Newman

SELECTED BIBLIOGRAPHY

BOOKS

Booth, Pat. *Master Photographers: The World's Great Photographers on Their Art and Techniques.* Interview with Arnold Newman. London: Macmillan Ltd., 1983.

Campbell, Bryn. "Arnold Newman." *World Photography: 25 Contemporary Masters Write About Their Work, Techniques and Equipment.* London: Hamblyn Publishing Group Ltd., 1981.

Diamonstein, Barbaralee. *Visions and Images: American Photographers on Photography.* New York: Rizzoli, 1981.

Fondiller, Harvey V., ed., with Beaumont Newhall and Arthur Goldsmith. *The Best of Popular Photography.* New York: Ziff Davis Publishing Company, 1979.

Newman, Arnold. *One Mind's Eye: The Portraits and Other Photographs of Arnold Newman.* Foreword by Beaumont Newhall; introduction by Robert Sobieszek. Boston: David R. Godine, 1974.

—— *Faces USA.* Garden City, N.Y.: American Photographic Book Publishing Company, 1978.

—— *The Great British.* Introduction by George Perry. London: Weidenfeld & Nicolson; Boston: New York Graphic Society, 1979.

—— *Artists: Portraits from Four Decades by Arnold Newman.* Foreword by Henry Geldzahler. Boston: New York Graphic Society, 1980.

—— *Arnold Newman: Five Decades.* Introduction by Arthur Ollman. New York, San Diego, and London: Harcourt Brace Jovanovich, 1986.

Newman, Arnold, with Robert Craft. *Bravo Stravinsky.* Cleveland, Ohio: World Publishing Company, 1967.

Sobieszek, Robert. *Arnold Newman.* The Great Photographers Series. Englewood Cliffs, N.J.: Prentice-Hall, 1982.

Weber, Bruce. *Arnold Newman in Florida.* West Palm Beach, Fla.: Norton Gallery of Art, 1987.

ARTICLES

(published after 1974; for earlier articles, see *One Mind's Eye,* 1974)

Allen, Casey. "An Interview with Arnold Newman." *Camera* (July 1976).

——. "Talking with Arnold Newman." *Studio Photography* (February 1989).

"Arnold Newman, Portrait Master." *The Photographic Journal* (October 1989).

Benedek, Yvette. "Contact: Arnold Newman." *American Photographer* (April 1981).

Clark, Roger. "Arnold Newman." *British Journal of Photography* (December 11, 1981).

Cook, James. "Newman's History-Making Environmental Photographs." *American Society of Magazine Photographers Bulletin* (August 1988).

Edwards, Owen. "A Mover Among the Shakers." *American Photographer* (November 1985).

Geldzahler, Henry. "The Photographer as Artist." *The Atlantic* (October 1980).

Goldsmith, Arthur. "Lesson in Portraiture from a Master." *Popular Photography* (December 1979).

Le Bar, Elizabeth. "Interview: Conversation with Arnold Newman." *Photographer's Forum* (September 1980).

Newman, Arnold. "Arnold Newman: 'The Camera Is Only a Tool.'" *Photogram* (March 1977).

——. "Portraits of Personality." *Horizon* (October 1988).

"One Man's Faultless Camera Eye." *Town & Country* (September 1988).

"On Photographing the President." *Esquire* (June 1975).

Perloff, Stephen. "Arnold Newman and the Dilemma of Portraiture." *The Philadelphia Photo Review* (October/November 1977).

"Photography – A Contemporary Compendium: Arnold Newman." *Camera* (November 1975).

Rittsel, P. "Arnold Newman." *Foto* (July-August 1982).

Schaub, Grace. "Arnold Newman." *Photographer's Forum* (November 1989).

Schonauer, D. "The Photographer Revealed." *American Photographer* (April 1989).

Schreiber, Norman. "Pop Photo Snapshots: Newman Cum Laude." *Popular Photography* (September 1981).

Sealfon, Peggy. "Meet the Masters: Arnold Newman." *Petersen's Photographic Magazine* (February 1983).

Solomon, Deborah. "Newman at Work." *American Photographer* (February 1988).

Zito, Tom. "A Photographer and His Surroundings." *Washington Post,* January 8, 1975; p. B9.

Zwingle, Erla. "Inspirations: Eight Photographers Talk About What Has Shaped Their Own Art." *Connoisseur* (January 1985).

ACKNOWLEDGMENTS

Our conversations with Arnold Newman about a collection for the National Portrait Gallery began on a warm summer evening in 1988, when Ira Lowe hosted an informal supper for the Newmans. Several years earlier I had tried — unsuccessfully — to persuade Arnold that the Portrait Gallery would be incomplete without a substantial representation of his work; this time he was receptive. Without the sustained enthusiasm, generosity, and patience of Arnold and Augusta Newman, this project would never have come to completion, and without Ira Lowe's encouragement, it would never have gotten started. The National Portrait Gallery, and those who will enjoy these photographs for years to come, owe them an incalculable debt of gratitude.

William F. Stapp was then the Gallery's curator of photographs, and he followed my initial contacts with a visit to Newman's studio in the spring of 1989. After fifteen years at the Portrait Gallery, Will departed for a new curatorial position at the George Eastman House in Rochester; but before he left, he, Arnold, and the Gallery's curator of exhibitions, Beverly Cox, had reviewed the hundreds of pages of Arnold's studio books, negatives, and prints to select the photographs that should be in the collection in Washington.

During his visits with Arnold, Will began a series of conversations intended to provide background for an introductory essay in this book. When Arnold was invited to be a visitor at the Institute for Advanced Study in Princeton, he and Will arranged for several days of intensive interviews, which were recorded and subsequently transcribed. This material has been invaluable in the preparation of the book, and I acknowledge my debt to Will; to Vandy Cook and Iris Jones, who fearlessly translated the tapes into typescript; and to Arnold, for sharing his time and his ideas so openly. Finally, I must acknowledge the elegant and pioneering essays on Arnold by Beaumont Newhall, Robert Sobieszek, Arthur Ollman, Henry Geldzahler, and Bruce Weber that — along with Arnold's own writings — have informed my own knowledge of Arnold and his photographs and have been fundamental sources for us in our work.

Alan Fern

INDEX

Library of Congress Cataloging-in-Publication Data

Newman, Arnold. 1918–
 [Americans]
 Arnold Newman's Americans/with essays by
 Alan Fern and Arnold Newman.—1st ed.
 p. cm.
 ''An exhibition at the National Portrait Gallery,
 April 15 through August 16, 1992''—T.p. verso.
 Includes bibliographical references and index.
 ISBN 0-8212-1899-9 (hc)
 ISBN 0-8212-1901-4 (pb)
1. Portrait photography—United States—Exhibi-
tions. 2. United States—Biography—Portraits.
3. Newman, Arnold, 1918– —Exhibitions. I. Fern,
Alan Maxwell, 1930–. II. National Portrait Gallery
(Smithsonian Institution). III. Title. IV. Title:
Americans.
TR680.N46 1992
779'.2'092—dc20 91-37744

Designed by Howard I. Gralla

Typeset by Finn Typographic Service in Futura Book

Printed on LOE Gloss by The Stinehour Press

Bound by Acme Bookbinding Company